THE MODERN ART

Doodle BOOK

Create your own masterpiece

THE MODERN ART *Doodle* BOOK

Create your own masterpiece

MICHAEL O'MARA BOOKS LIMITED

First published in Great Britain in 2012 by
Michael O'Mara Books Limited
9 Lion Yard
Tremadoc Road
London SW4 7NQ

A CIP catalogue record for this book is available from the British Library.

Papers used by Michael O'Mara Books Limited are natural, recyclable products made from wood grown in sustainable forests. The manufacturing processes conform to the environmental regulations of the country of origin.

ISBN: 978-1-84317-590-2 in paperback print format

1 2 3 4 5 6 7 8 9 10

Cover design by Dave Crook
Designed and typeset by Dave Crook
Introduction by Brian Bomeisler

Printed and bound in China by Wing King Tong

www.mombooks.com

Be Inspired by *The Modern Art Doodle Book*

By Brian Bomeisler

Do you like to doodle? Not only is it a fun thing to do, it's also a great outlet for your creativity. Whether you're a part-time scribbler or a budding artist, *The Modern Art Doodle Book* will inspire you to create your own drawings in the styles of some of our greatest modern artists.

Ideal for all ages and abilities, this book contains fifty-six artworks by thirty different artists. On some pages you'll find fragments of a masterpiece to help get you started; other pages have been left blank to let your drawings run free.

If you're unsure of the best place to start, why not take a look at Paul Gauguin, Pablo Picasso or Vincent van Gogh – these pages contain more fragments of the original artworks to help guide you through your doodles.

It's up to you how you approach each doodle. You might decide to copy each artwork – a time-honoured approach to learning painting and drawing – or you might prefer to pick-up clues from the original and let your imagination run free.

There are also a number of techniques you can use to help get you started. Why not try turning the book upside down. This will allow your brain to concentrate on shapes, colours and lines, rather than the artwork as a whole – you'll be amazed at the results! Or you might try covering your drawing-hand with a towel – your view of the doodle will be obscured, forcing you to concentrate on following carefully the lines of the artwork; the shift in your perception should enable you to record all of the undulations in the image. But don't peek under the towel until you feel you've completed the drawing!

Be inspired by the different colours and line styles of these great masters and try to interpret them in your own way. You will then create original work from your own unique observations.

Use whatever medium you have available: pencil or coloured pencils; charcoal or charcoal pencils; a black writing pen or coloured felt-tip pens. Watercolour or acrylic paint will work well, too. But, most of all, let your creativity flow and **HAVE FUN!**

Brian Bomeisler

Lead Instructor, Drawing on the Right Side of the Brain Workshops

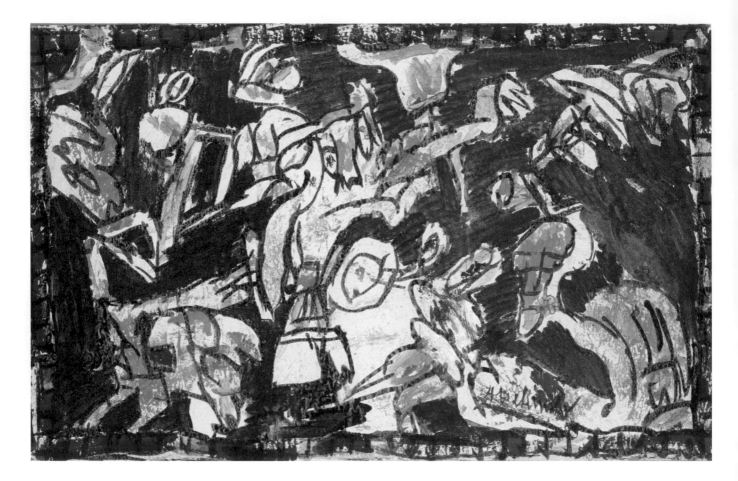

Particular Gravitation, 1981

Pierre Alechinsky (1927–)

Pierre Alechinsky is a Belgian painter, printmaker, draughtsman and film-maker, whose work is associated with abstract expressionism – an American post-World War II art movement. He was a founding member of COBRA, an avant-garde, Marxist-inspired group formed in Paris in 1948, which rejected Western culture and drew its inspiration from primitive art forms and from the work of **Paul Klee** and **Joan Miró**. Alechinsky often uses ink in the centre of his paintings, reserving colour paint for the edges (although before 1972 he used the reverse of this technique). Constantly experimenting with new ideas, his work possesses a haphazard style, his use of quick-drying acrylic paint enabling him to work at speed.

Pierre Alechinsky

Pierre Alechinsky

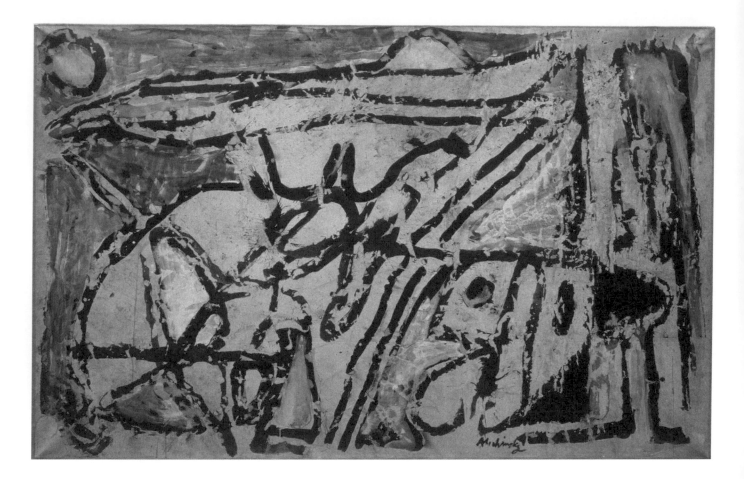

In Ink Country, 1959

In Ink Country, 1959 © ADAGP, Paris and DACS, London 2011

Pierre Alechinsky

Pierre Alechinsky

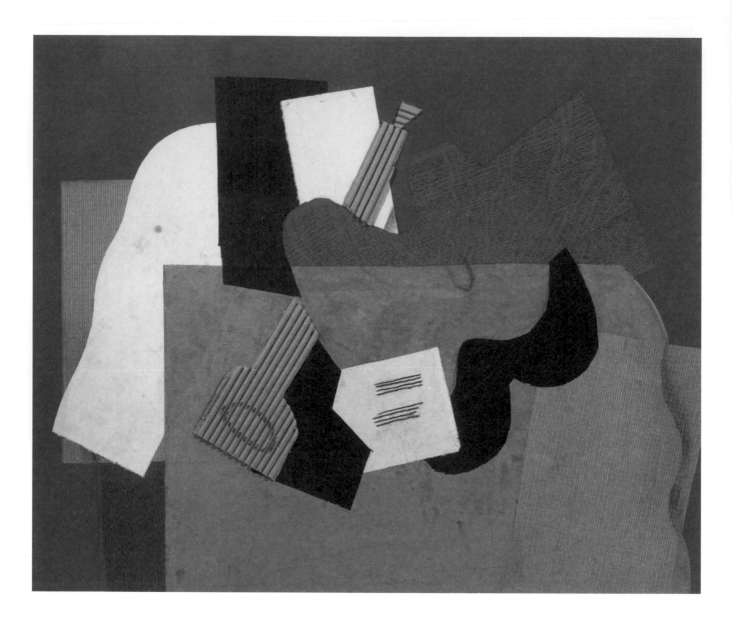

Guitar and Clarinet, 1918

Georges Braque (1882–1963)

The French artist Georges Braque initially painted in the impressionistic style, but in the early 1900s fell under the influence of the Fauve movement ('the Beasts'), a short-lived art movement, led by **Henri Matisse** and André Derain, which promoted the use of strong colour; however, he was also strongly influenced by the post-impressionist painter and 'father of modern art' Paul Cézanne. Braque was a friend of **Pablo Picasso**, and from 1908 they pioneered cubism, a movement inspired by geometry and by experimenting with Cézanne's theory of multiple perspectives. Post-World War I Braque developed a freer style of cubism, using intense colours. From 1939 he became more detached from painting and focused on sculpture and pottery. Like Picasso, Braque is regarded as one of the pioneers of modern art.

Georges Braque

Georges Braque

Georges Braque

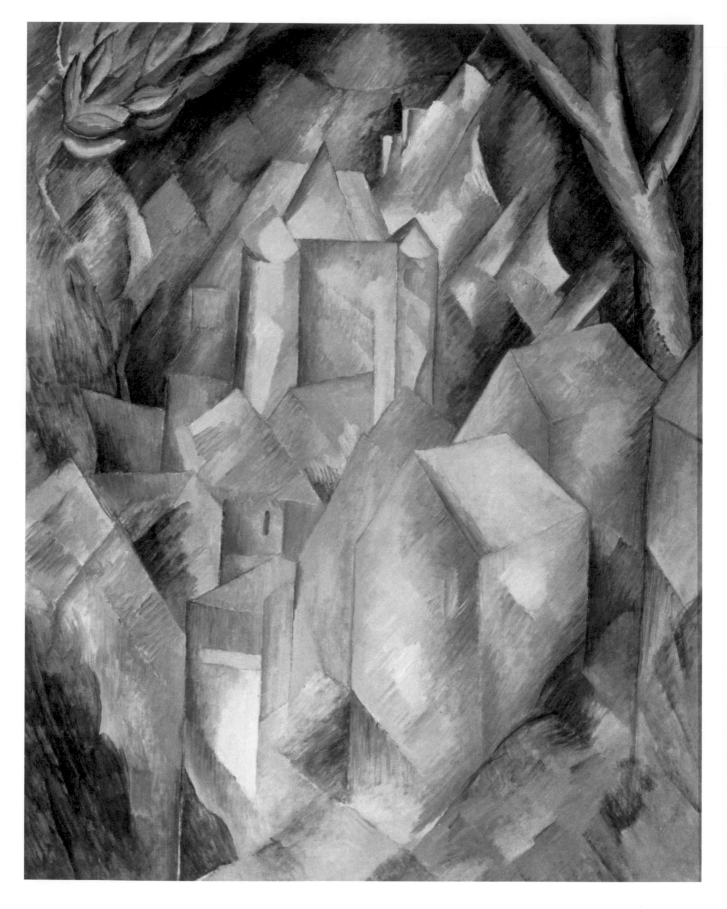

Château de la Roche-Guyon, 1909

Georges Braque

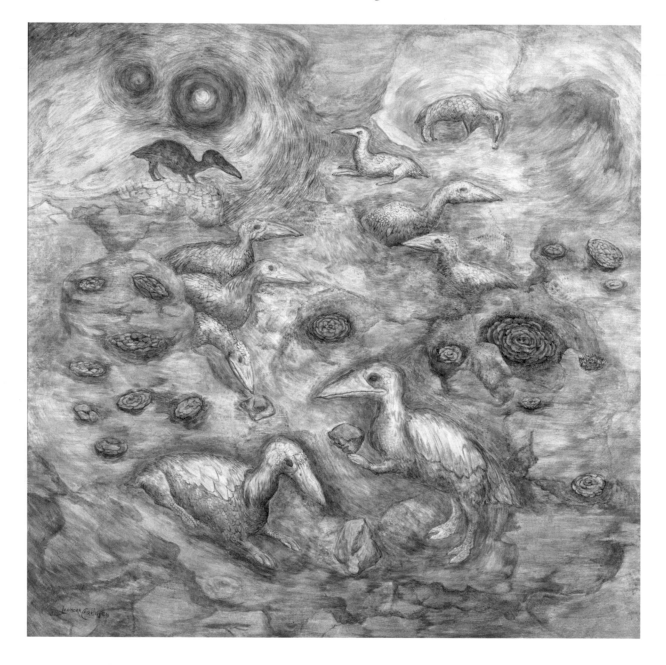

Desert Dorgys, 1986

Leonora Carrington (1917–2011)

The British-born painter Leonora Carrington was the longest-surviving, as well as one of the greatest, of the surrealists. At the age of nineteen she eloped with **Max Ernst** to France, where she befriended **Pablo Picasso, Joan Miró** and **Salvador Dalí,** and became heavily involved in the avant-garde art scene, a movement interested in experimental ideas and methods. She fled the Nazis during World War II and moved to Mexico – by way of a spell in an asylum in Spain – where she remained until her death. Carrington was inspired by myth and religious ritual and her paintings mixed dream and reality. Her work had a dark undercurrent, with the Victorian Gothic house of her childhood featuring often; however, she also used vivid colours in juxtaposition with sometimes monstrous figures.

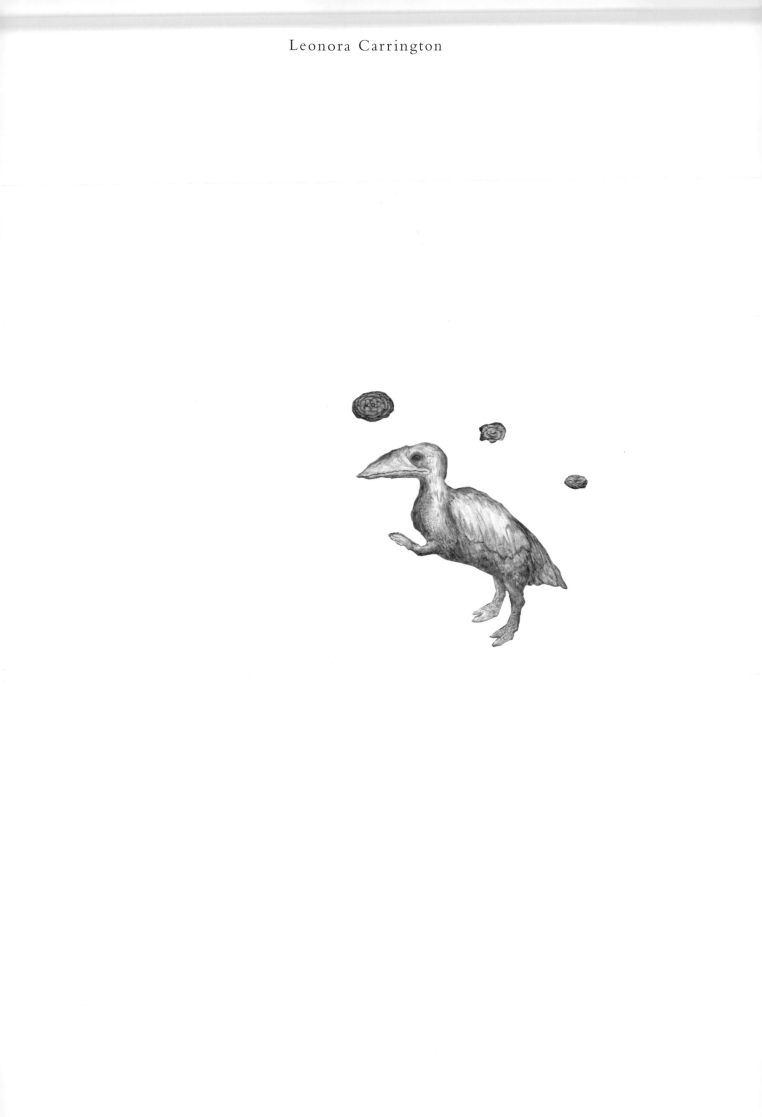

Leonora Carrington

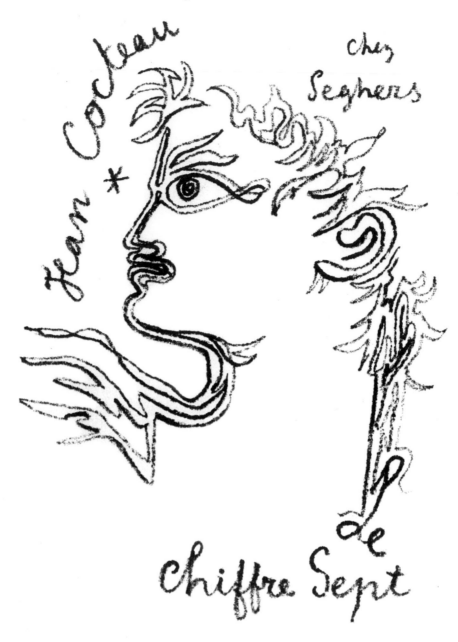

Front cover of *Le Chiffre Sept*, 1952 © ADAGP, Paris and DACS, London 2011. Avec l'aimable
autorisation de M. Pierre Bergé, président du Comité Jean Cocteau

Jean Cocteau (1889–1963)

Jean Cocteau was a French poet, novelist, playwright, designer, film-maker and artist.
A leading figure in Parisian Bohemian circles, he counted **Pablo Picasso** and **Amedeo
Modigliani** among his friends. He was an accomplished painter of murals and, although
he denied being a surrealist, he shared many qualities with artists associated with that
movement. His work also displayed cubist influences, especially in its use of distorted
form and space, and his drawing favoured simplified figures and heavy black outlines.
Cocteau battled with opium addiction and died of a heart attack on the same day he
learned of the death of his great friend, the famous Parisian torch singer Edith Piaf.

Jean Cocteau

Clown With Guitar, date unknown

Jean Cocteau

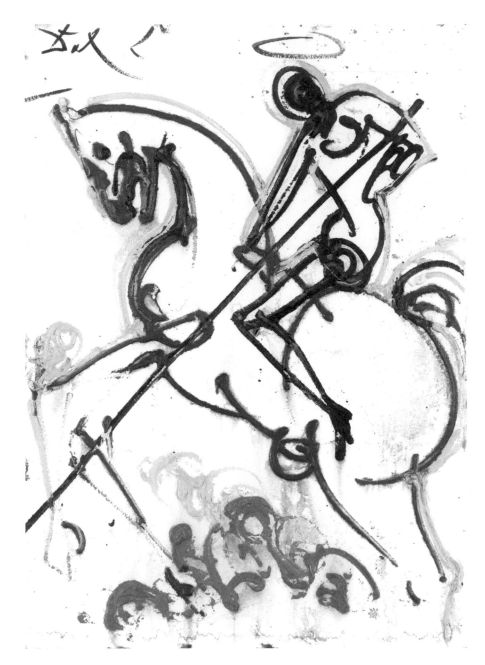

St George, date unknown © Salvador Dalí, Fundació Gala-Salvador Dalí, DACS, 2011

Salvador Dalí (1904–89)

The Spanish Catalan painter Salvador Dalí first experimented with cubism, but in 1930, by which time he was based in Paris, he joined the surrealist movement, which hoped to free art from the constraints of convention. While Dalí would become one of the group's most recognized artists, he clashed with them over his refusal to condemn Fascism and was expelled in 1934; he would later leave France to escape the Nazi invasion. Dalí worked in many different media, including watercolour and performance art. His works were filled with complex symbols and phantom realities, but his primary interest in death and the fragility of human existence, notably when he lived in America from 1940 to 1948, later gave way to a concern with science, religion and history. Today his best-known works are his dream landscapes, often featuring symbolic objects such as melting pocket watches. He lived out his remaining years in Catalonia.

Salvador Dalí

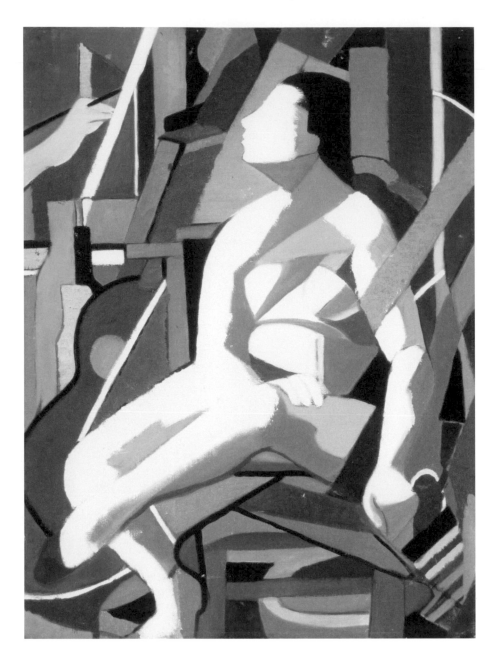

Model in the Studio, date unknown © 2011 Tamara Art Heritage/ADAGP, Paris and DACS, London

Tamara de Lempicka (1898–1980)

The Polish painter Tamara de Lempicka was the grande dame of art deco, whose social life was as legendary as her art. After a stint in Paris, de Lempicka based herself in the USA from 1939 onwards, and she became one of the most fashionable portrait painters of her generation. Her subjects were duchesses, Grand Dukes and socialites, whom she admired for their elegance and decadent lifestyles. Influenced by the 'soft cubism' of André Lhote and the 'synthetic cubism' of Maurice Denis, de Lempicka's paintings had a cool yet sensual flare, often characterized by themes of desire and seduction. She considered Picasso's style to be 'destructive' and rejected the 'dirty' colours employed by the impressionists, choosing instead to paint with clean lines using light and bright colours, with a high gloss, and often choosing powerfully built models as her subjects.

Tamara de Lempicka

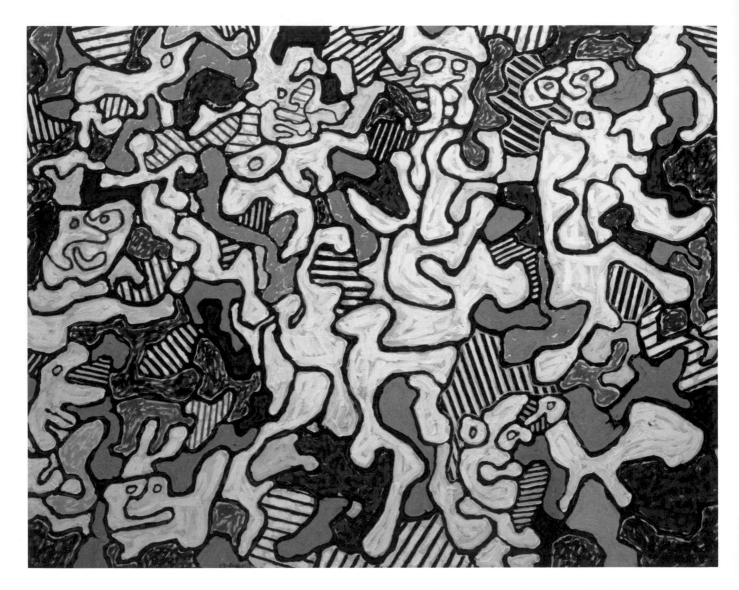

Mouchon Berlogue, 1963

Jean Dubuffet (1901–1985)

The French avant-garde painter and sculptor Jean Dubuffet was a winemaker before taking up art full-time in 1942. He went through a number of artistic phases, producing a series of paintings that looked like jigsaw puzzles in the 1960s (the '*Hourloupe*' cycle), before he moved on to sculpture. Many of Dubuffet's works were assemblages, in which he collected together different objects to make one whole piece, and he was known for using paint thickened by added ingredients, such as tar and sand. Inspired by paintings by the psychologically disturbed, Dubuffet collected such pieces of *art brut* ('raw art') and emulated their brutality and directness of style in his own work.

Jean Dubuffet

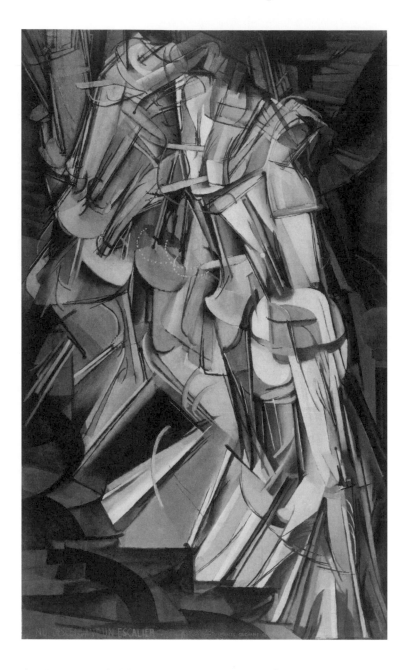

Nude Descending Staircase Number Two, 1912 © ADAGP, Paris and DACS, London 2011

Marcel Duchamp (1887–1968)

The great joker of modern art, Marcel Duchamp was an influential French artist whose work foreshadowed Dada – an artistic movement that emphasized the illogical and the absurd – surrealism and abstract expressionism. His early work was cubist in style, although his figures differed from those of other cubists as they seemed to move in perpetual motion. Duchamp's most famous pieces, which came to redefine art, were his 'readymade' works, in which he exhibited mundane household items as art forms in themselves; notoriously, in 1917 he submitted a urinal under the title *Fountain* to an influential exhibition in New York. Duchamp's works were full of satire and he had an innovative approach to art, combining different materials in one piece. He was the adviser to many art collectors, most notably the American heiress Peggy Guggenheim. In the early 1920s he relinquished art in favour of playing chess.

Marcel Duchamp

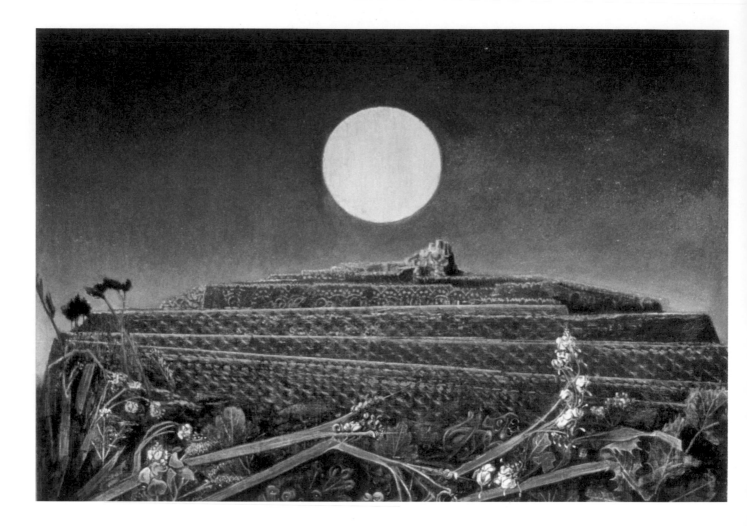

Die Ganze Stadt, 1935–6 © ADAGP, Paris and DACS, London 2011

Max Ernst (1891–1976)

The German artist Max Ernst was a painter, sculptor and printmaker and a leading surrealist who helped shape the emergence of abstract expressionism in post-World War II America. He had no formal artistic training, yet his academic background in philosophy and psychology led him to use painting as a cathartic practice. The horrors of his military service in World War I had a profound affect on Ernst and he used his experiences as inspiration for his apocalyptic scenes. He developed a new technique called '*frottage*' (rubbing) in which a soft pencil is rubbed over paper resting on a textured surface. He left France – to which he had moved from Germany in 1922 – for the USA after the Nazi invasion, but returned in 1953, by which time he had amassed a huge critical following. Ernst had a particularly strong influence on **Jackson Pollock**.

Max Ernst

Max Ernst

Gala Eluard, 1926

Max Ernst

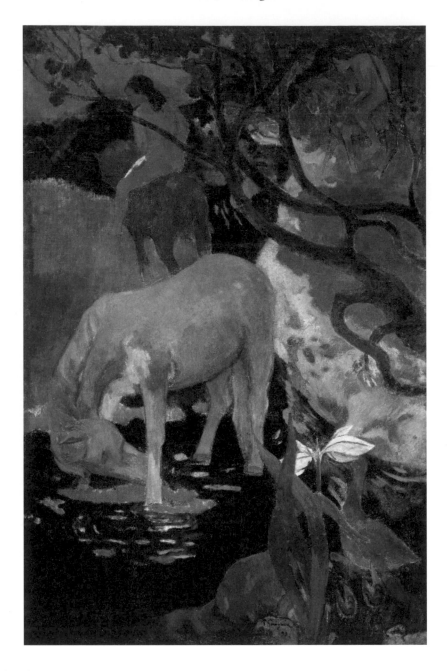

The White Horse, 1898

Paul Gauguin (1848–1903)

The French artist Paul Gauguin was a sculptor, printmaker, ceramist, and writer, as well as a leading post-impressionist painter. He was a key member of the symbolist movement, which promoted the use of symbolic images to represent ideas. Gauguin had a number of jobs before turning to painting full time in 1885, and he shared an intense friendship with **Vincent van Gogh**, although the latter threatened him with a razor the night he cut off his own ear. Disappointed with impressionism's lack of depth, Gauguin, like **Pablo Picasso**, sought the influence of primitive art forms, which brought him to 'cloisonnism', a style of painting that favoured the use of flat forms in strong colours separated by dark outlines. In 1895 he abandoned his family and escaped to French Polynesia, where he painted until his early death, possibly from syphilis.

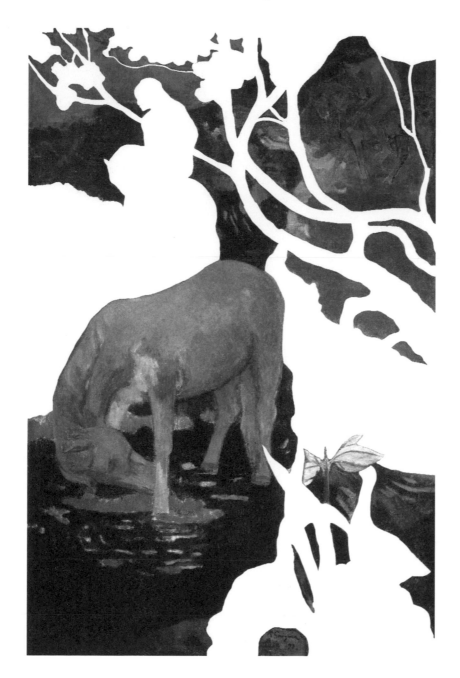

Blending colours: Using your chosen medium, try merging the soft tones of the blues and greens to create a fluid effect.

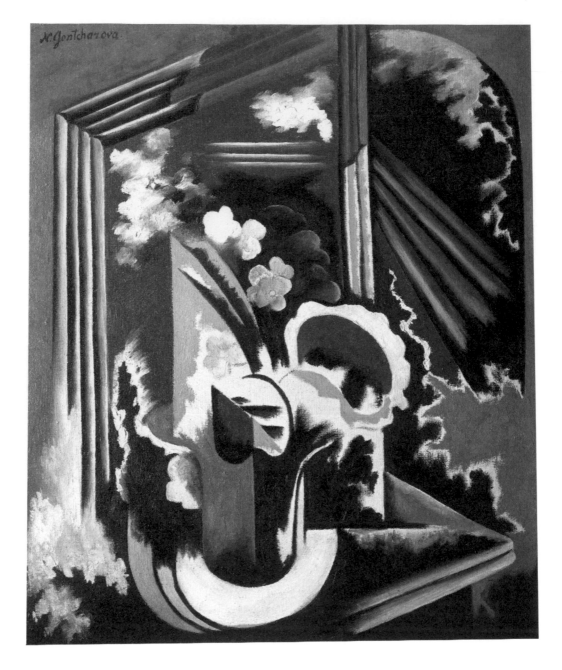

Rayonist Flowers, 1914

Natalia Goncharova (1881–1962)

Natalia Goncharova was a Russian artist, theatre and textile designer and a leading member of the Moscow Futurists, followers of an artistic and political movement that had originated in Italy in 1909, intent on expressing the energetic and violent qualities of contemporary life. Although originally training as a sculptor, she took to painting, and was influenced by the work of **Paul Gauguin**, the colours used by the Fauve movement, cubism, and the primitive aspects of Russian folk art. In 1911, with her husband, the avant-garde Russian painter Mikhail Larionov, Goncharova developed Rayonism, a style of art that aimed to go outside time and space by filling works with movement and rays of contrasting colours executed with rapid brushwork. Goncharova moved to Paris in 1921 – she later became a French citizen – and continued to work there until her death.

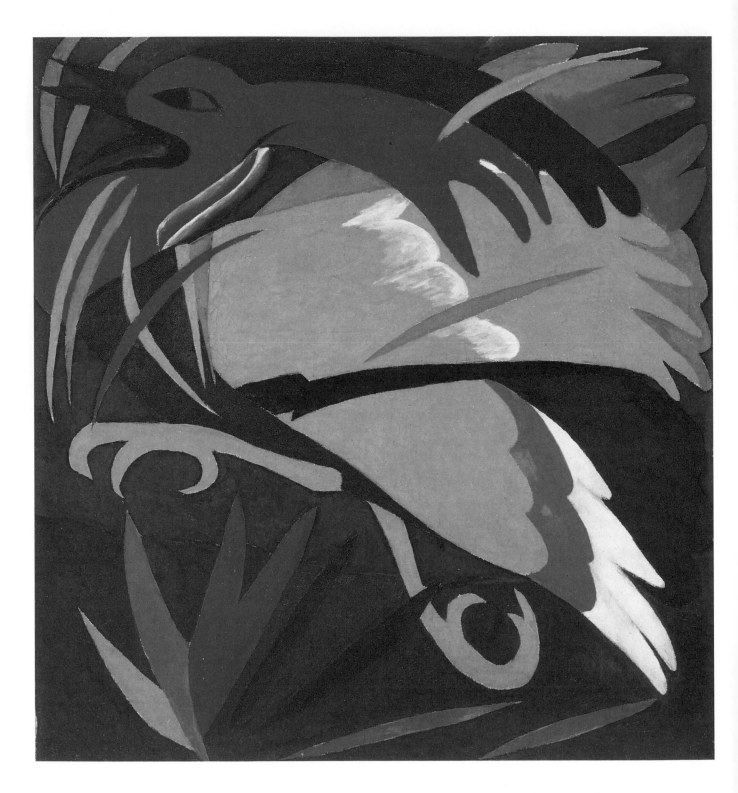

The Reaping. Phoenix, 1911

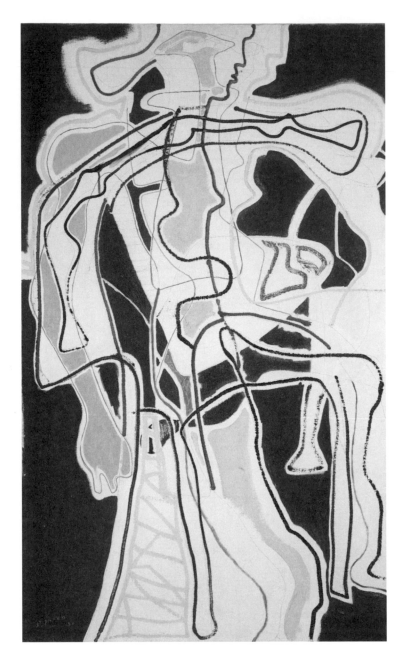

Nude in Wicker Chair: 1951, 1950–1

Patrick Heron (1920–99)

Patrick Heron was an English painter, art critic and designer. Cézanne, and to a lesser extent **Georges Braque**, would serve as Heron's greatest influences, but his work was also informed by the colours used by the Fauve movement. He also admired the confident brushwork, bright colours and huge canvases of the American abstract expressionists. Having moved from London to Cornwall in 1956, inspired by the landscape's hues and bright light, Heron used blocks of pure colour to represent space. As a committed socialist, he was concerned in all his work with freedom of expression and creativity, but also with structure and design, although many of his paintings had an unfinished quality, and he often used a restricted palette.

Patrick Heron

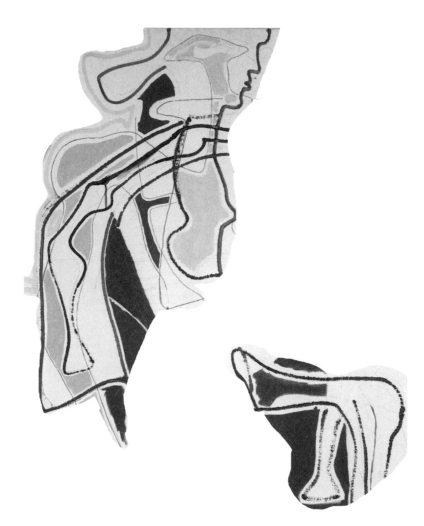

Patrick Heron

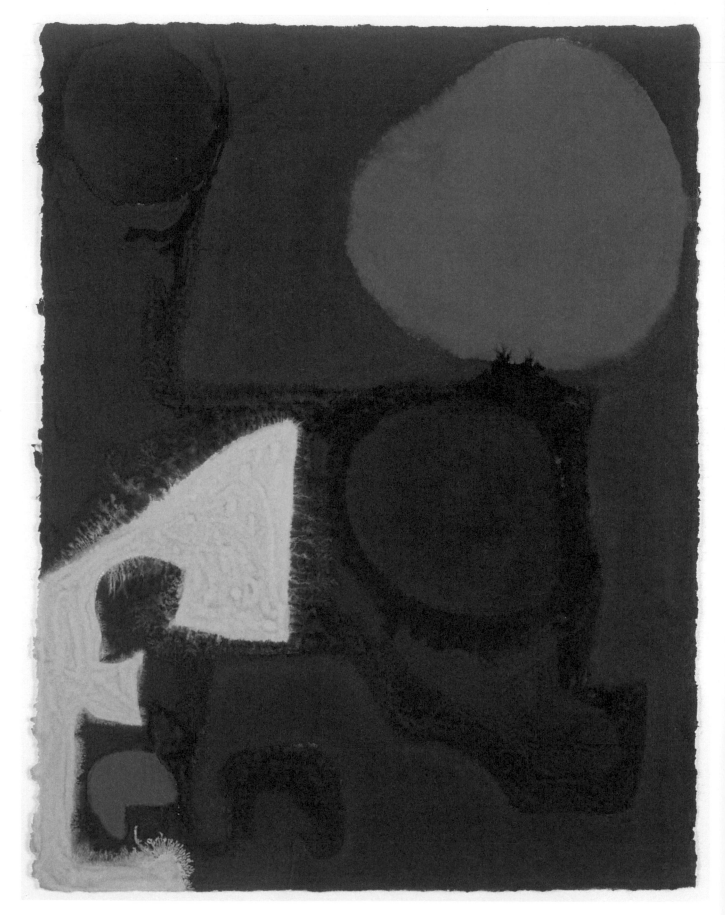

Icy Emerald Cutting into Dark Green and Blue

(Cobalt and Violet Discs): November 1968, 1968

Patrick Heron

Patrick Heron

Patrick Heron

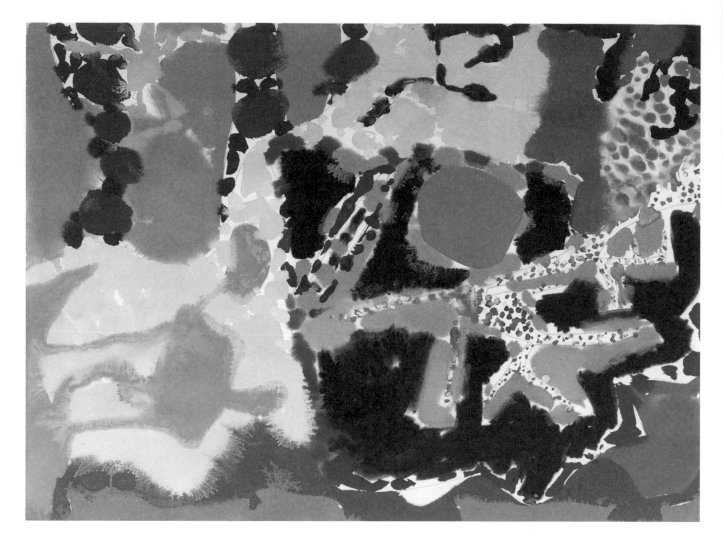

January 19: 1989, 1989

Patrick Heron

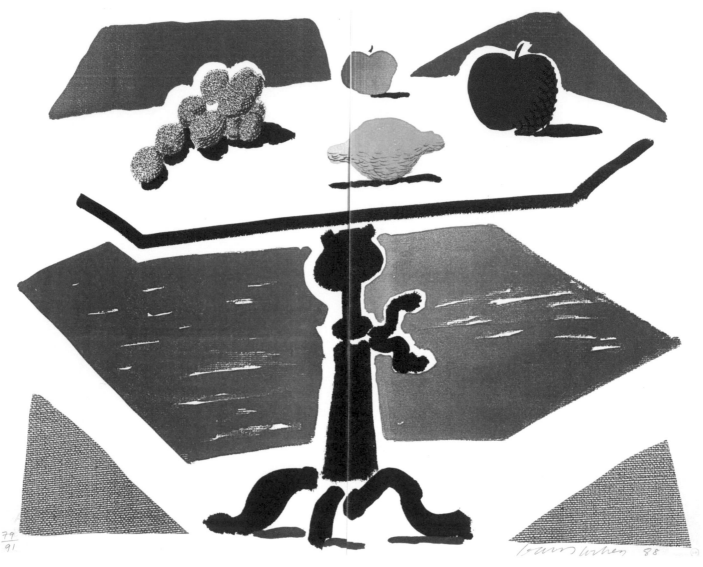

Apples, Grapes, Lemon on a Table (for Bam), 1988
(home-made print on two sheets of paper)

© David Hockney

David Hockney (1937–)

The British artist David Hockney has spent much of his career in America, although he is now based in London and his native Yorkshire. Inspired by the abstract expressionists, Hockney, along with his friend Andy Warhol, was a major contributor to the 1960s Pop Art movement, which formed as a reaction to the elitism of the art world. Hockney has also been influenced by California, filling his paintings with athletic young men, swimming pools and mountains. His work is characterized by its vibrant colours and cryptic qualities, and he uses his art to express his emotions. His early paintings often included poetry, which soon gave way to declarations of love and confessions of homosexuality. Noted for his portraits, landscapes and still lifes, he is also a photographer, collage artist and printmaker, as well as designing for the stage and 'painting' directly on computers. Today he is known for a naturalistic, realistic style.

David Hockney

David Hockney

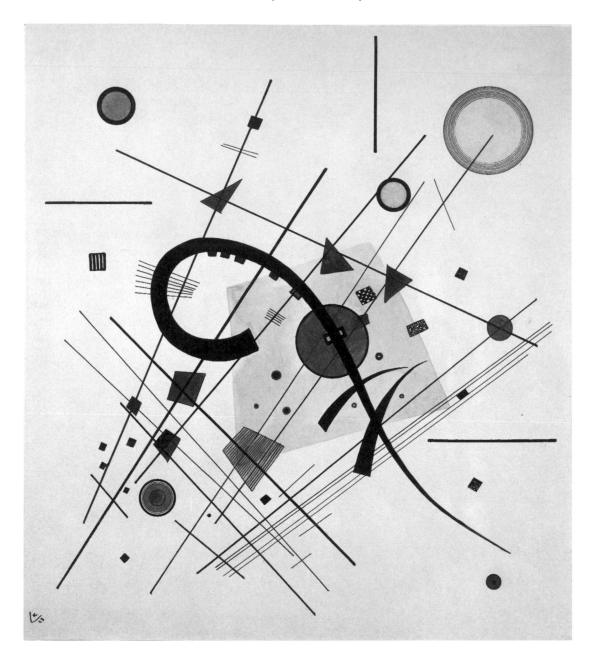

Graues Viereck, 1923 (B.a 620)

Wassily Kandinsky (1866–1944)

The Russian artist Wassily Kandinsky took up painting in his late twenties, moving to Germany in 1896, although he returned to Moscow in 1914 on the outbreak of World War I. His early work was realistic in style, but gradually it became more abstract. He was a founding member of the expressionist Blue Rider group, an art movement that sought to express spiritual truth through emotion and vibrant colour. In 1921 he returned to Germany to teach at the Bauhaus, where he joined **Josef Albers** and **Paul Klee**, and on its closure by the Nazis in 1933 he moved to Paris, where he remained until his death. Kandinsky did not like to paint from life, concentrating instead on abstract shapes and colour. A leading artistic and spiritual theoretician, he attached meaning to everything: colours, lines and symbols all denoted feelings and sensations; even the direction and size of a brushstroke could stand for an idea or an emotion.

Wassily Kandinsky

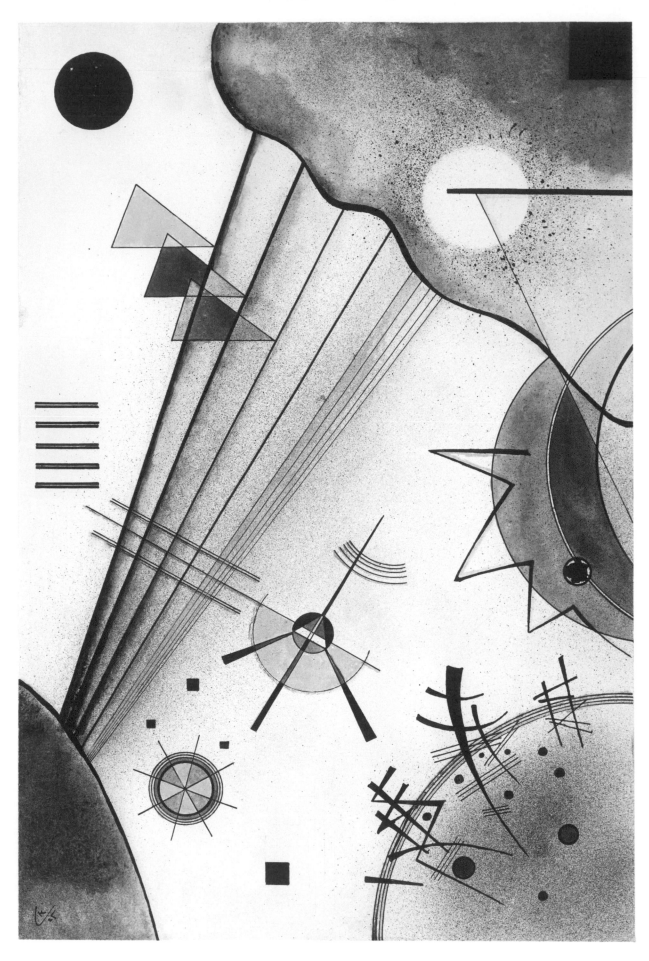

Deutliche Verbindung, 1925 (B.a 768)

Wassily Kandinsky

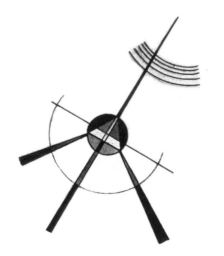

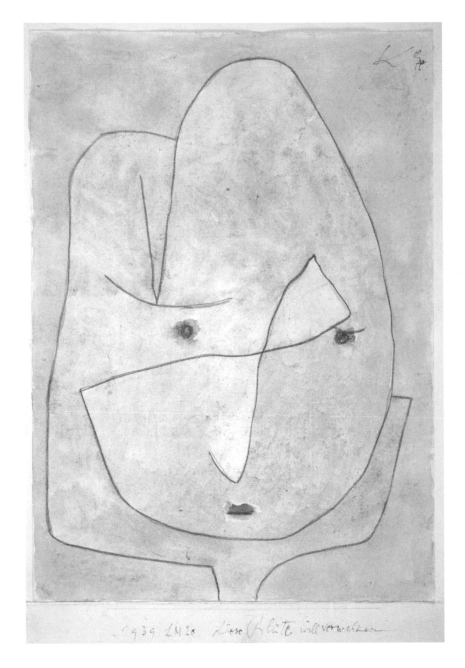

The Flower Wishes to Fade, 1939

Paul Klee (1879–1940)

Paul Klee was born in Switzerland but attended art school in Germany. Influenced by many styles, he never considered himself part of any movement, although he was involved with the expressionist Blue Rider group. He travelled widely and, after returning from one trip to Tunisia in 1914, began to paint with warmer colours using dramatic contrasts of light and shade. From 1920 he taught and worked at the Bauhaus, alongside **Josef Albers** and **Wassily Kandinsky**, but left in 1931 to take up a professorship in Düsseldorf. Labelled a 'degenerate' artist by the Nazis in 1933, he moved with his family to Bern in Switzerland, where he died. As an artist he was inspired by modern graphic design, and also by the efforts of children as yet uninfluenced by artistic training. He tried to replicate a childlike style in his own work, believing a child's ideas to be less restrained than his own.

Paul Klee

Paul Klee

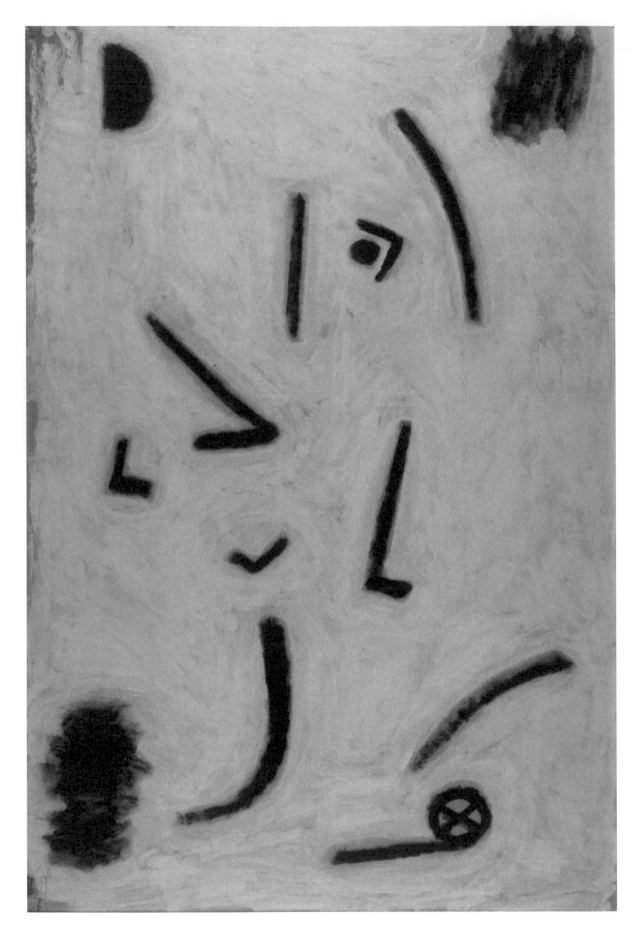

Symbols on a White Background, 1940

Paul Klee

Paul Klee

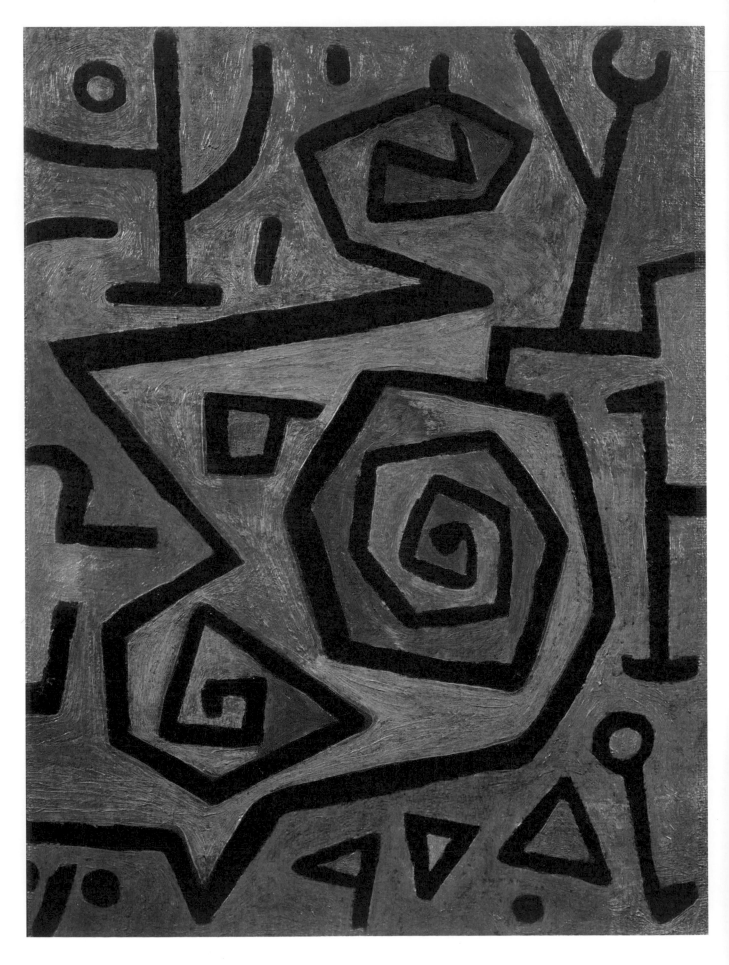

Heroic Roses, 1938

Paul Klee

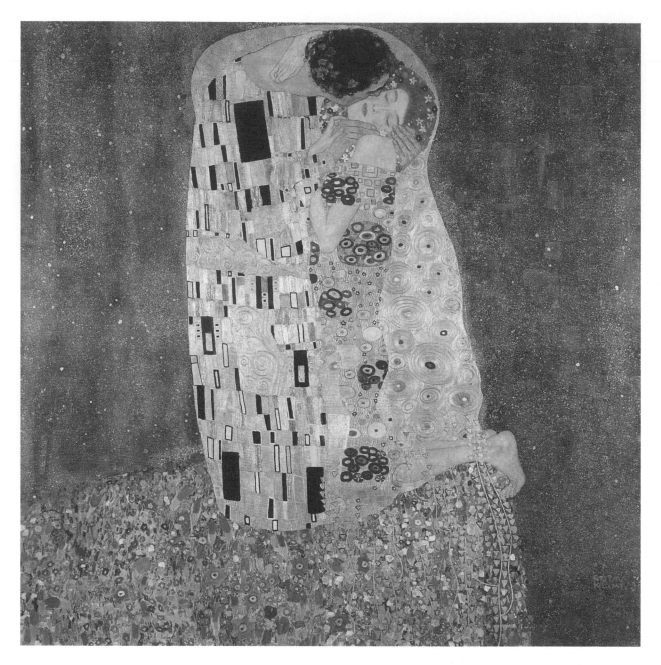

The Kiss, 1907–8

Gustav Klimt (1862–1918)

The Austrian artist Gustav Klimt began his career as an architectural decorator in Vienna. Rejecting the traditional conventions of the Viennese schools of art, he founded the Vienna Secession movement. The Secession artists encouraged no particular style (Klimt, for instance, was a symbolist), its aim being to exhibit the work of young or foreign artists. Klimt combined the realistic with the abstract, placing recognizable figures in strange settings. Inspired by ancient art from Greece, Byzantium and Egypt, he included mosaic-like patterns in his paintings and a large amount of gold leaf. Much of his art explored themes of love, sensuality and death, in works that were often considered so shocking that many refused to display them; late in life he also took up landscape painting, partly influenced by his early training as an architectural painter. He died in February 1918, a victim, like **Egon Schiele**, of the flu pandemic of 1918–20.

Gustav Klimt

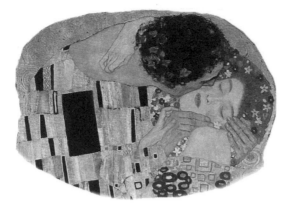

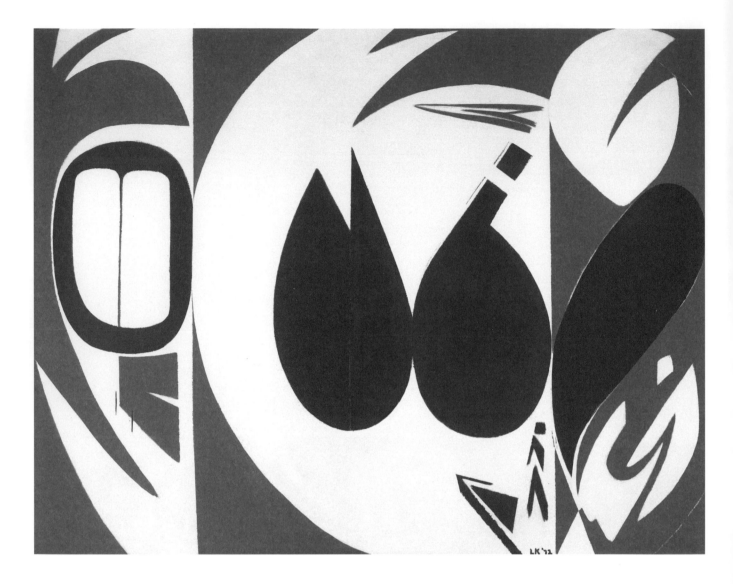

Mysteries, 1972

Lee Krasner (1908–84)

The American painter Lee Krasner was married to **Jackson Pollock** and was herself a
leading abstract expressionist. She studied cubism before she turned to freer forms of
expression, employing the 'all-over' style that her husband used; she began showing her
works with the American Abstract Artists, a group devoted to promoting the
understanding of abstract art, in 1940. Krasner often cut apart her work and used the
fragments to create collages – a revival technique inspired by **Henri Matisse**. Her
paintings, characterized by vigorous brushwork and bold colours, are dynamic and full
of expression and emotional energy. Pattern became a key element in her work and
she also incorporated ancient forms of writing such as Hebrew into her paintings.

Lee Krasner

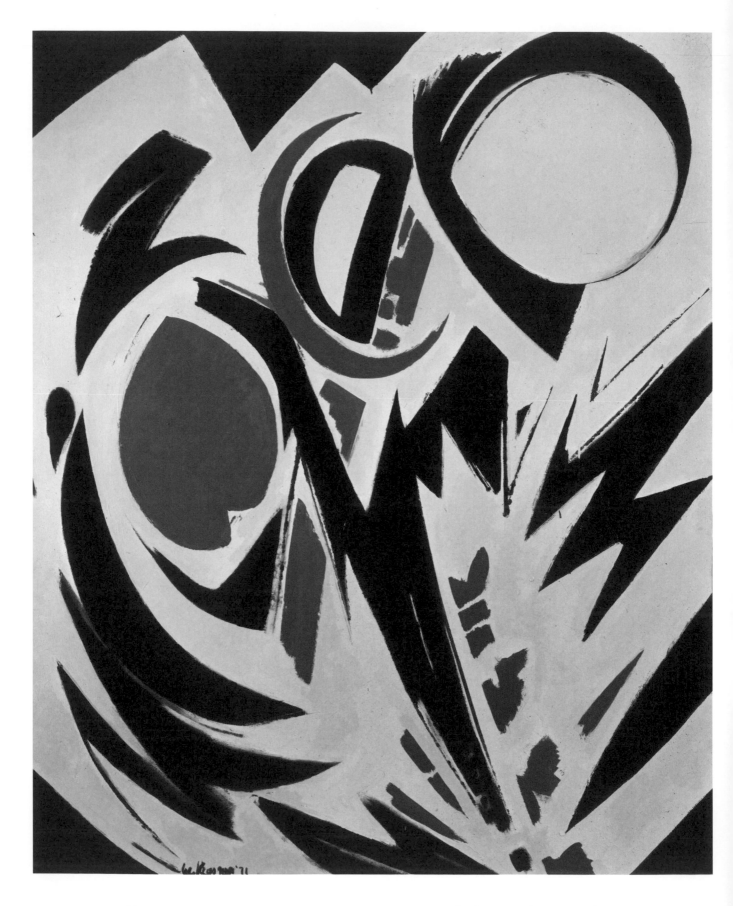

Meteor, 1971

Lee Krasner

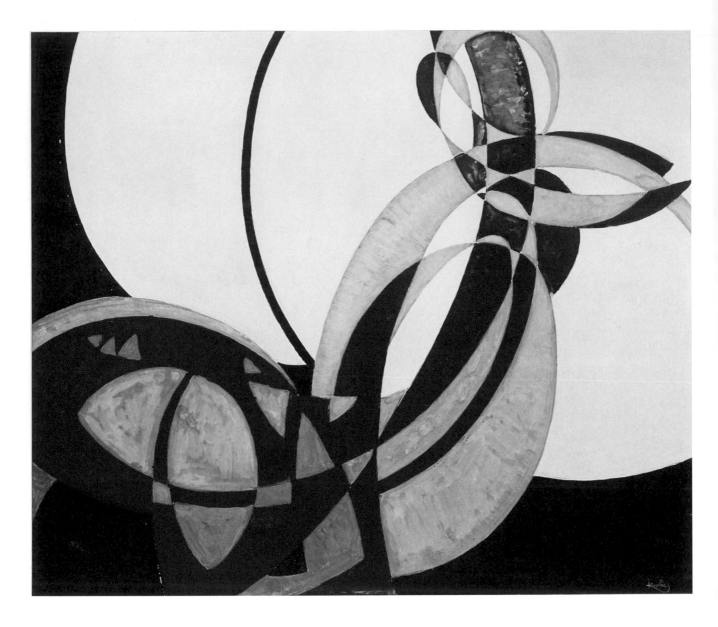

Maquette for *Fugue in Two Colours*, 1912 © ADAGP, Paris and DACS, London 2011

František Kupka (1871–1957)

František Kupka was a Czech painter and illustrator who started work as a caricaturist and created fashion designs, posters and illustrations before becoming a painter. He settled in Paris in 1906, where he became a pioneer of the early phases of the abstract-art movement and of Orphism, a short-lived offshoot of cubism that favoured pure abstraction and bright colours. Kupka was also inspired by Futurism, Czech folk art, philosophy and optics, and in 1931 became a founder-member of Abstraction-Création, an informal group of artists, including **Wassily Kandinsky** and Piet Mondrian, formed in Paris as a reaction against surrealism. He had a keen interest in colour theory and devised his own colour wheels. He also favoured patterns and contrasts, and employed bold colours to create interlocking geometric shapes, with thick jagged outlines and no shading.

František Kupka

František Kupka

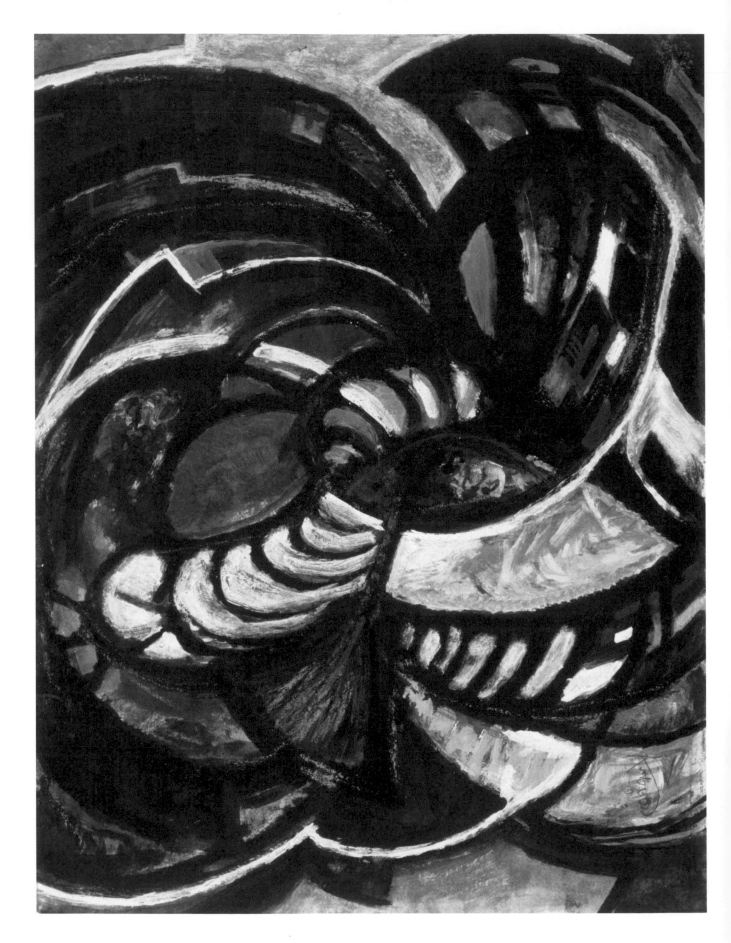

Study for *Around a Point*, date unknown

František Kupka

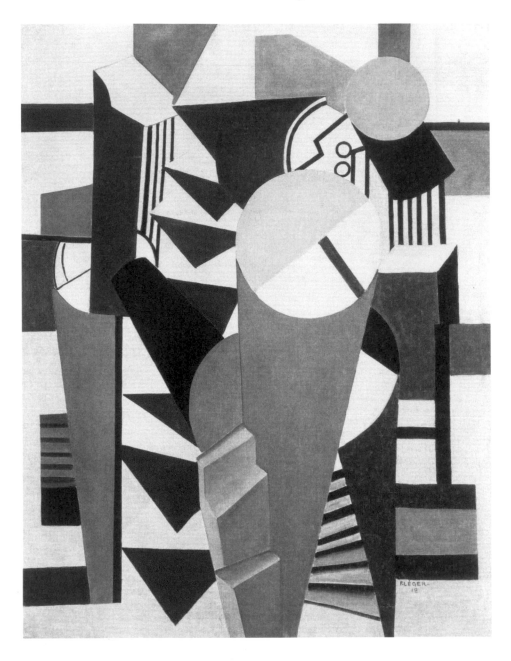

Composition, date unknown

Fernand Léger (1881–1955)

The French painter and sculptor Fernand Léger believed that art should not just be a luxury reserved for the wealthy, and much of his work is devoted to depicting ordinary people in everyday situations. Born in Normandy, he first trained as an architect, and only began painting seriously in his mid-twenties. Early in his career, he experimented with the impressionist style but after the Cézanne exhibition of 1907 he was inspired to change his approach. Exposed to the work of **Pablo Picasso** and **Georges Braque**, he began to paint more like the cubists, building his subjects from tube shapes, which led many to mock his style as 'tubism'. Employing heavy outlines and solid colours, he often depicted modern city life and was fascinated by its new machinery. Léger also painted murals, designed theatre and film sets – he was a co-director of the Futurism-inspired film *Ballet Mécanique* (1924) – and worked in stained glass.

Fernand Léger

Fernand Léger

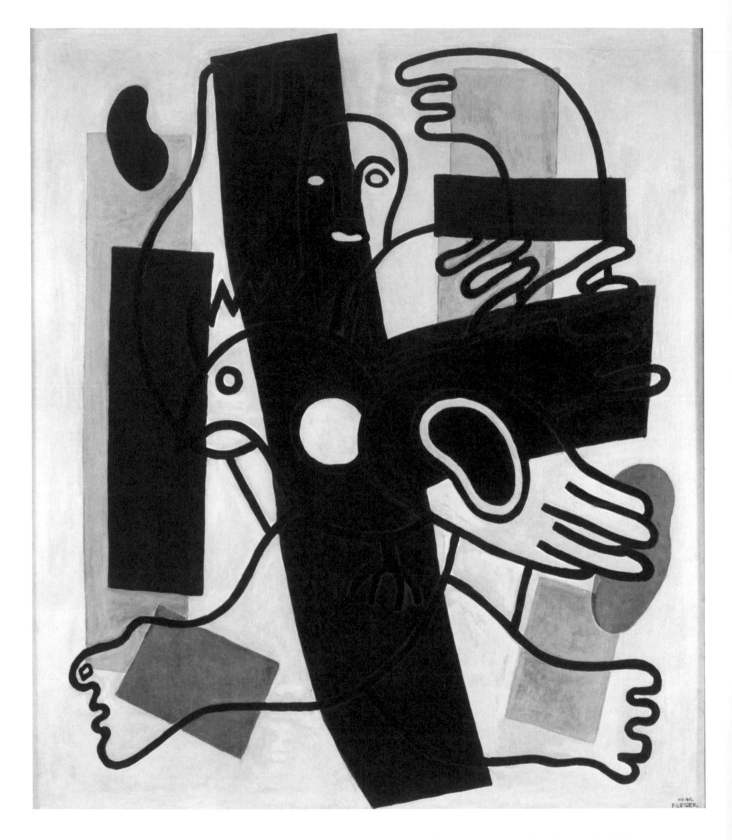

Untitled, 1942

Reclining Nude, 1980

Roy Lichtenstein (1923–97)

The American pop artist Roy Lichtenstein studied art at Ohio State University, and went on to teach art in universities for several years. His work from 1961 challenged traditional understanding of art by taking popular culture as material for his paintings. Success came swiftly: at his one-man show in New York in 1962 all his paintings were snapped up, although, because much of his work involved making slight alterations to existing images, many dismissed it as derivative. In his early years Lichtenstein had experimented with cubism and German expressionism before settling on abstract expressionism. Unlike most abstract expressionists, however, he began to incorporate figures into his work. His paintings were also characterized by flying spaceships, snippets of text, heavy black outlines, bold colours and Ben-Day dots. His approach to art was both innovative and influential, and won him widespread international fame.

Roy Lichtenstein

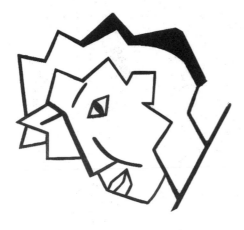

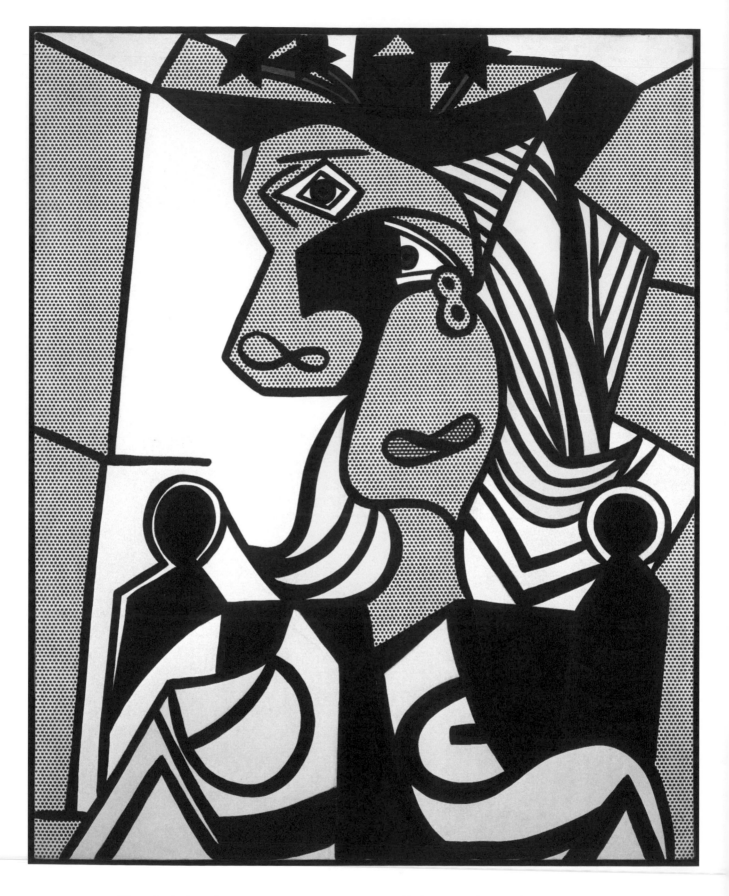

Woman With Flowered Hat, 1963

Roy Lichtenstein

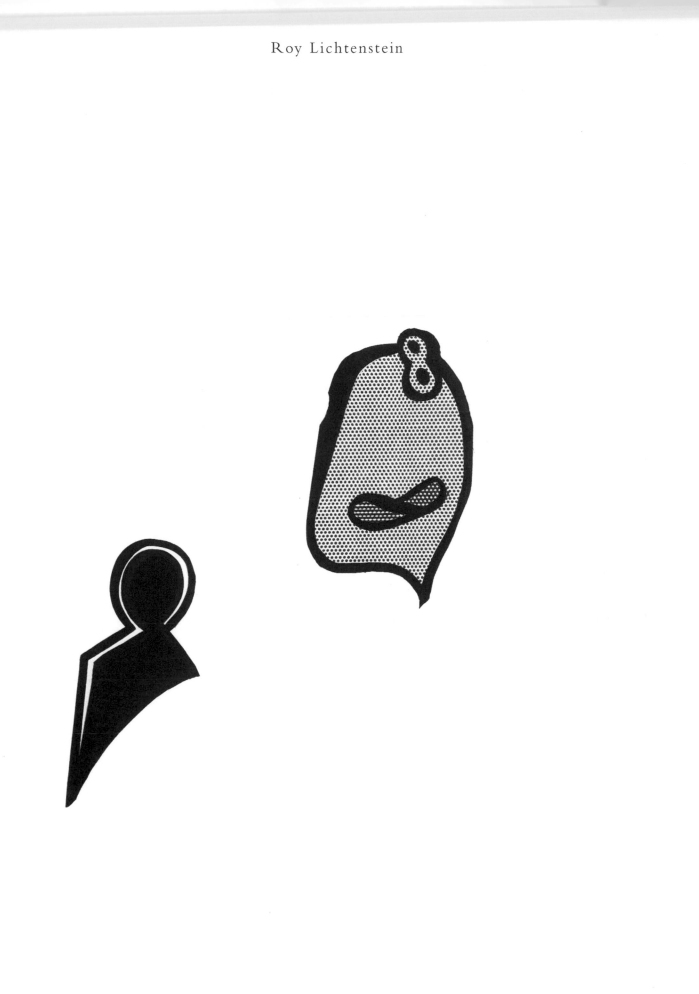

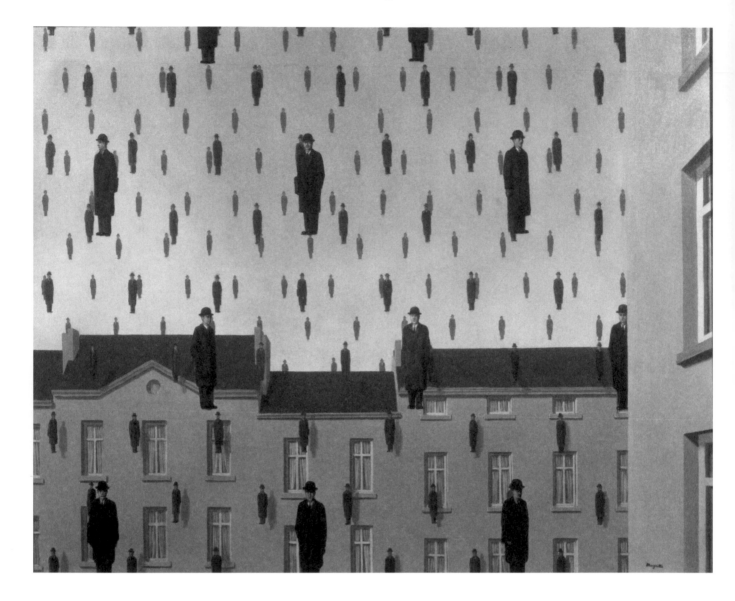

Golconda, 1953

René Magritte (1898–1967)

The Belgian surrealist artist René Magritte challenged the public's perception of reality by mixing wit and illusion in his paintings. He studied art in Brussels, and his early work was influenced by Futurism and one of the offshoots of cubism. Following stints as a draughtsman, a designer and in advertising, Magritte returned to painting in the surrealist style by the end of 1948. By 1965 his work had become widely known and appreciated. Magritte is known for his flat compositions and inexpressive brushstrokes, which impart a dreamlike quality to his painting. Yet, unlike other surrealists, he did not paint visions, but familiar props of everyday life, given human proportions and placed in strange settings. Having weathered scathing criticism at the beginning of his career, he lived to see his paintings admired as some of the most thought-provoking pieces of the twentieth century.

René Magritte

Le principe d'Archimède, 1952

René Magritte

René Magritte

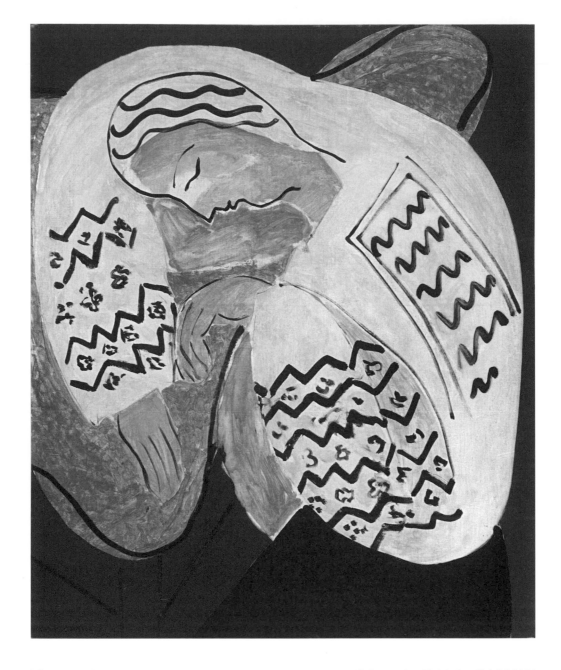

The Dream, 1940

Henri Matisse (1869–1954)

The French painter and sculptor Henri Matisse was, with his friend **Pablo Picasso**, one of the most important influences on twentieth-century art. He was a leading member of the Fauve movement, a group that favoured the bold use of colour and unrestrained brushwork in reaction against impressionism. Having initially trained in law, Matisse began to paint in 1889, and studied art in Paris from 1891. His early paintings were traditionally representational, and it wasn't until 1905 that his reputation began to grow. In 1917, Matisse moved to the South of France, where his work became more simplified. Matisse drew directly from nature and used colour as a means of expression. He favoured nudes and still lifes but eliminated much detail, and he painted on a large scale with big sweeping brushstrokes. Later on in his life, he turned to découpage; he also worked as an illustrator and produced many lithographs.

Henri Matisse

Henri Matisse

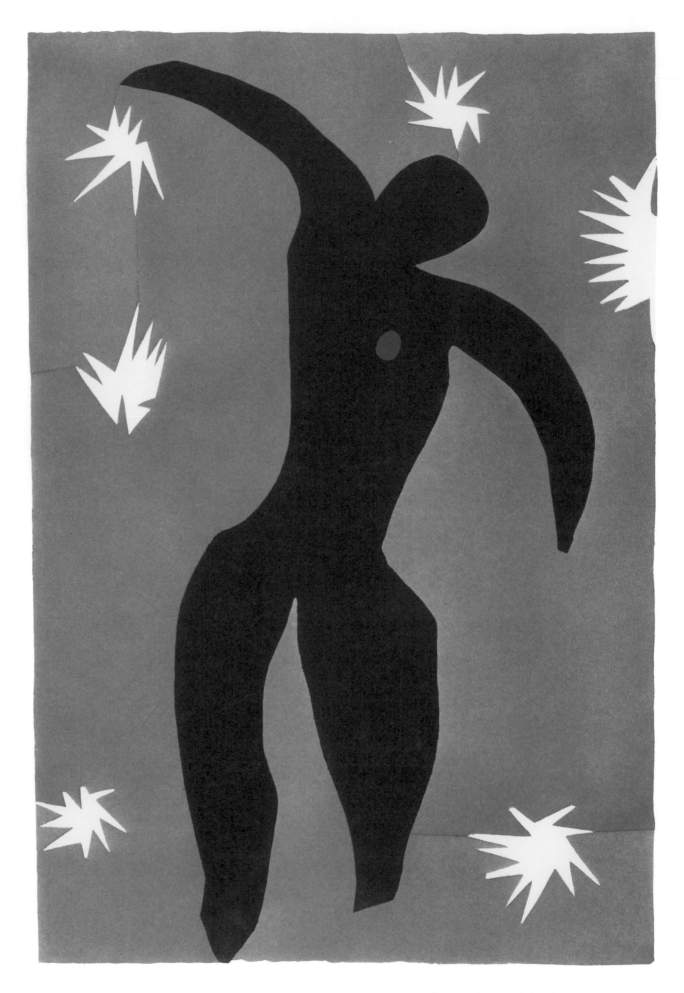

Icarus, 1947

Henri Matisse

Henri Matisse

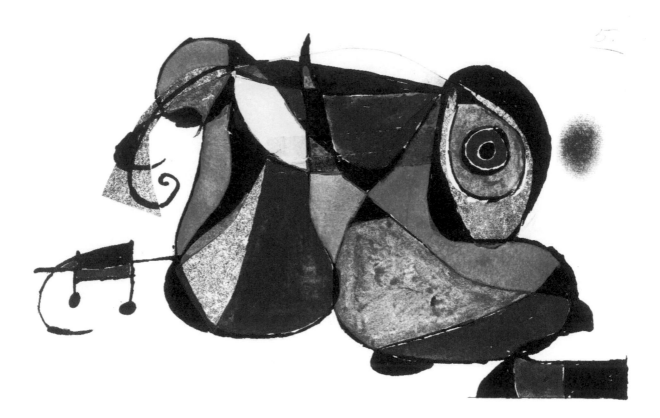

Model for Gaudí VI, c. 1975

Joan Miró (1893–1983)

The Spanish Catalan artist Joan Miró, although often described as a surrealist, in fact chose not to be associated with any movement. He studied both business and art in Barcelona, but settled on art in 1912. In 1920 he moved to Paris, and four years later joined the surrealist movement. He also experimented with collage, and in 1926 collaborated with **Max Ernst** on designs for a ballet, while he also began making etchings and surrealist sculptures, as well as working in ceramics. His work was included in major exhibitions in New York in 1936, and again in 1941, by which point he had returned to Spain. Much of his later career was taken up with ceramics and sculpture, but he also made prints and murals. Miró was inspired by his native Spain, especially in the works of Antoni Gaudí, and in early art from Catalonia. He painted dreamlike scenes in which brightly coloured forms float in mid-air, and he favoured round organic shapes and fine lines.

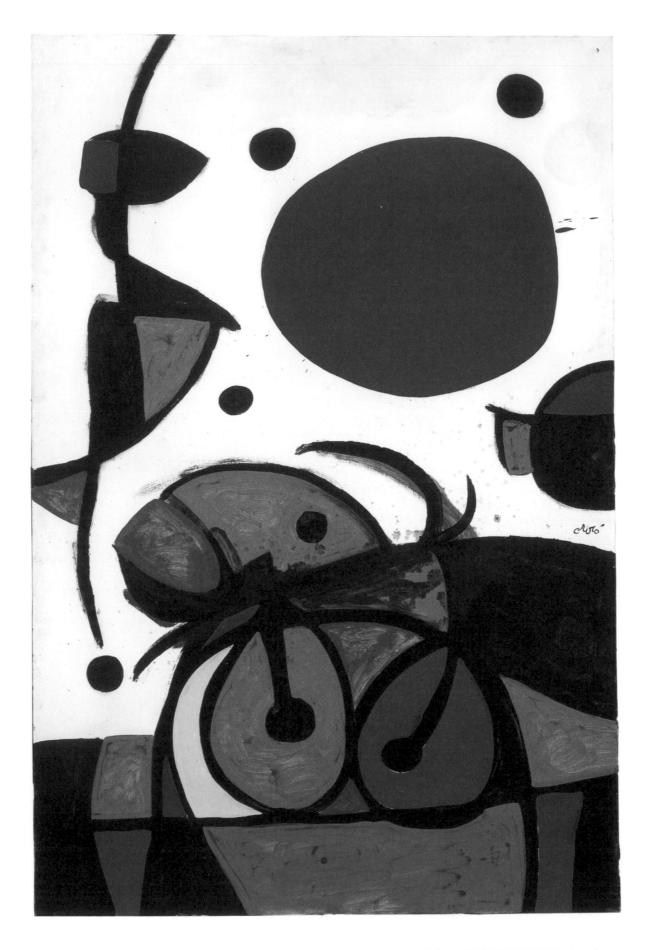

Figure and Birds in Front of the Sun, 1976

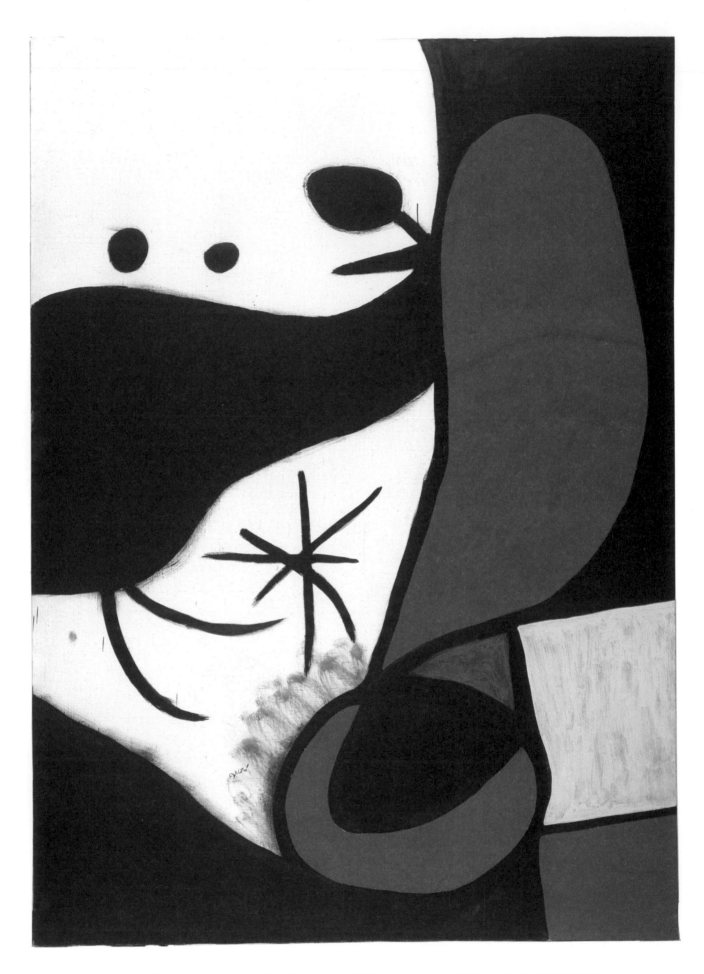

Woman and Birds in a Landscape: 1970, 5 September 1974

Joan Miró

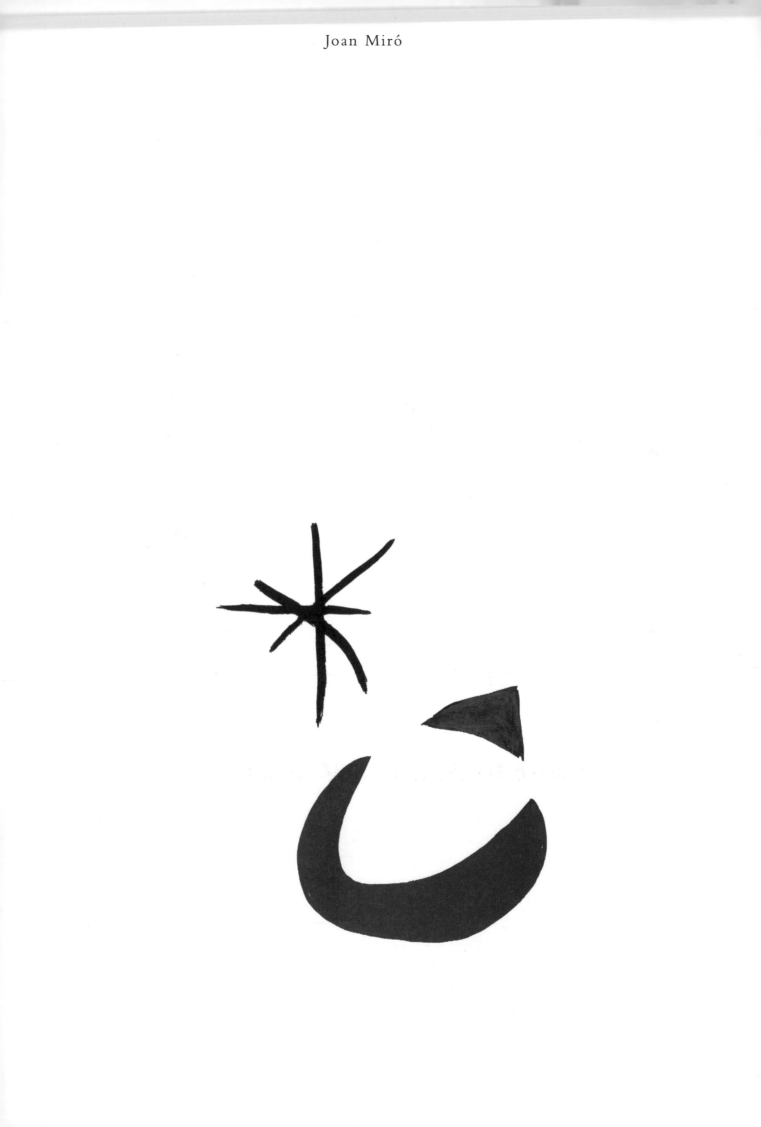

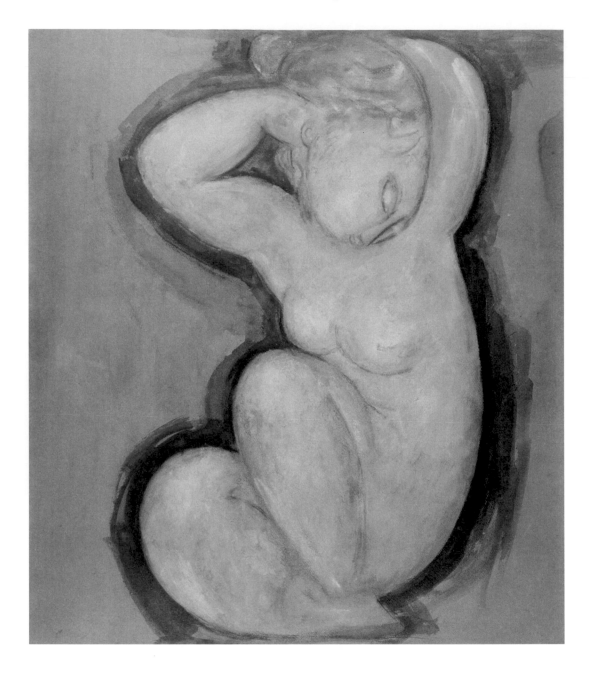

Caryatid, c. 1912–3

Amedeo Modigliani (1884–1920)

The Italian painter and sculptor Amedeo Modigliani was born in Livorno where, despite suffering from ill health from an early age, he studied painting. Influenced by the French impressionists and their Italian equivalent, the Macchiaioli, he moved to Paris in 1906 where he discovered the work of the cubists. He lived in considerable poverty and became a Bohemian figure, feverishly working despite becoming addicted to alcohol and drugs. Modigliani's early works were sculpted faces, which reflected his interest, like **Pablo Picasso**, in the linear form of African masks. By 1914 he reverted to painting, primarily figurative works. His subjects are immediately recognizable from their elongated limbs, long faces and wide eyes. He employed a bold palette and instead of shading, placed strong colours side by side to create the illusion of space. Modigliani died from tubercular meningitis aged thirty-five, having sold relatively few works during his lifetime.

Amedeo Modigliani

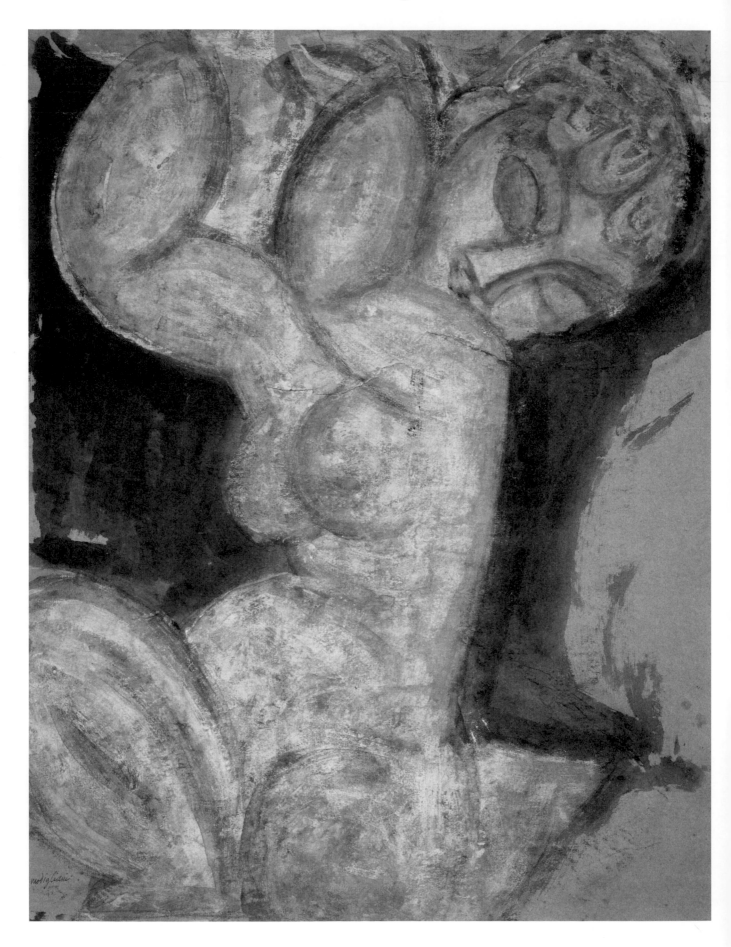

Nude Caryatid, 1913

Amedeo Modigliani

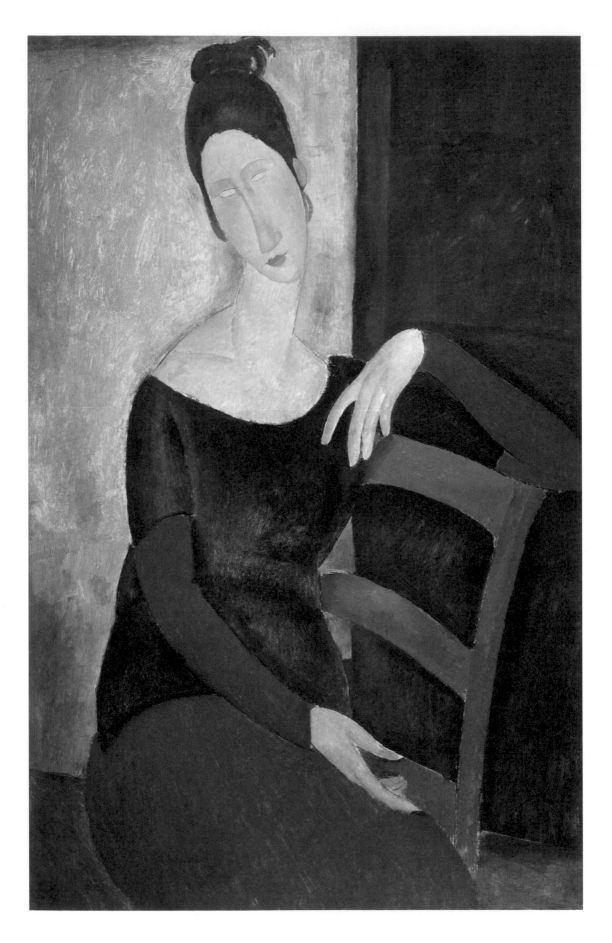

The Artist's Wife (Jeanne Huberterne), 1918

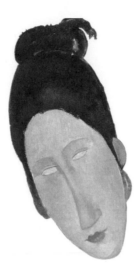

Amedeo Modigliani

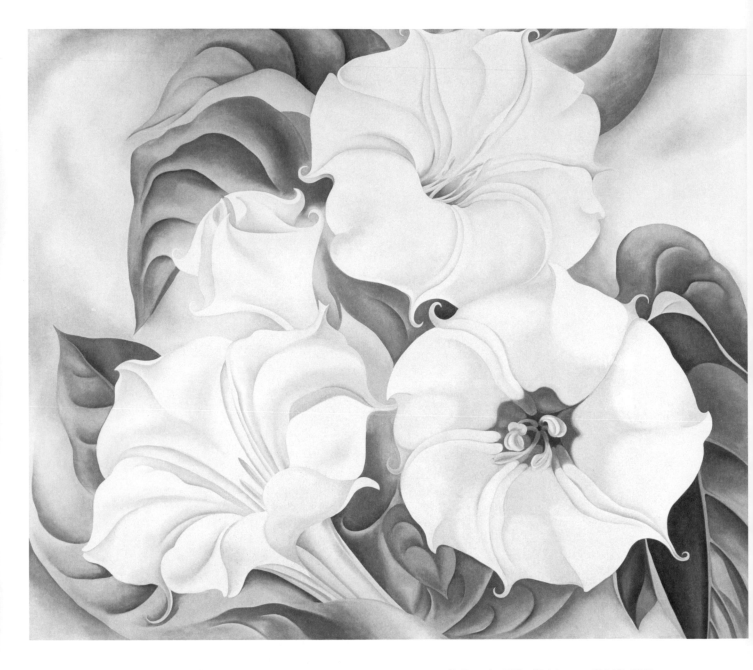

Jimson Weed, 1936–7 © Georgia O'Keeffe Museum/DACS, 2011

Georgia O'Keeffe (1887–1986)

The American artist Georgia O'Keeffe played an important role in the development of modernism in America, and is seen as its first female artist. Born in Wisconsin, she studied art in Chicago and painting in New York. In 1908 she began work as a commercial artist until, in 1912, she returned to painting and teaching. O'Keeffe did not adhere to an art movement, combining both realism and abstraction in her work. She began by painting cityscapes of New York before deciding to make intimate studies of flowers. But it was the barren landscape of New Mexico that really inspired her, and she chose to settle there in 1949. O'Keeffe gathered rocks, bones and wild flowers from the desert and began to recreate the natural world in her work, painting with precision and with a vibrant palette, often on a large scale. In 1977 President Ford bestowed on her the Presidential Medal of Freedom, the USA's highest civilian award.

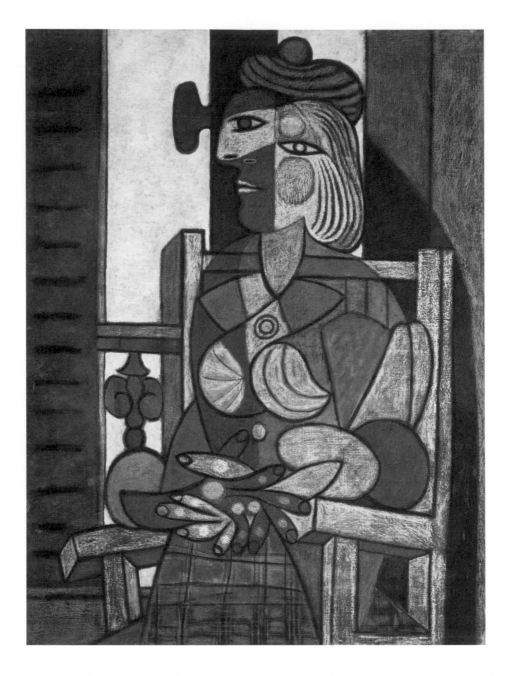

Woman Seated in Front of a Window, 1937 © Succession Picasso/DACS, London 2011

Pablo Picasso (1881–1973)

The Spanish painter and sculptor Pablo Picasso was perhaps the greatest single influence upon modern art. He was born in Malága, and aged thirteen began his formal artistic training, but stopped aged sixteen. In 1900 he went to Paris, where he was influenced by the work of Paul Cézanne, and where he befriended **Henri Matisse** and **Georges Braque**. Together, Picasso and Braque developed cubism, breaking up their subjects and reassembling them to offer different viewpoints. Although Picasso's cubist period lasted only from 1909 to 1912, the movement was to have a profound effect upon modern art and culture. Picasso had started as a realistic painter, moving to his representational Blue Period (1901–4) and then to the Rose Period (1904–6), in both of which a single colour predominated. From 1907–9 he produced work inspired by African art. Picasso created thousands of artworks, including ceramics and stage designs.

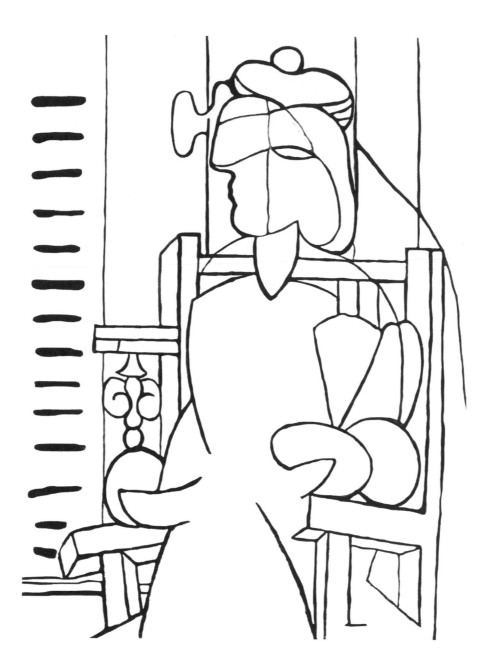

Focus on colour: For this first page the main outlines are drawn out for you.
Whatever medium you choose (coloured pencils, pastels or acrylic paint),
be inspired by Picasso's palette.

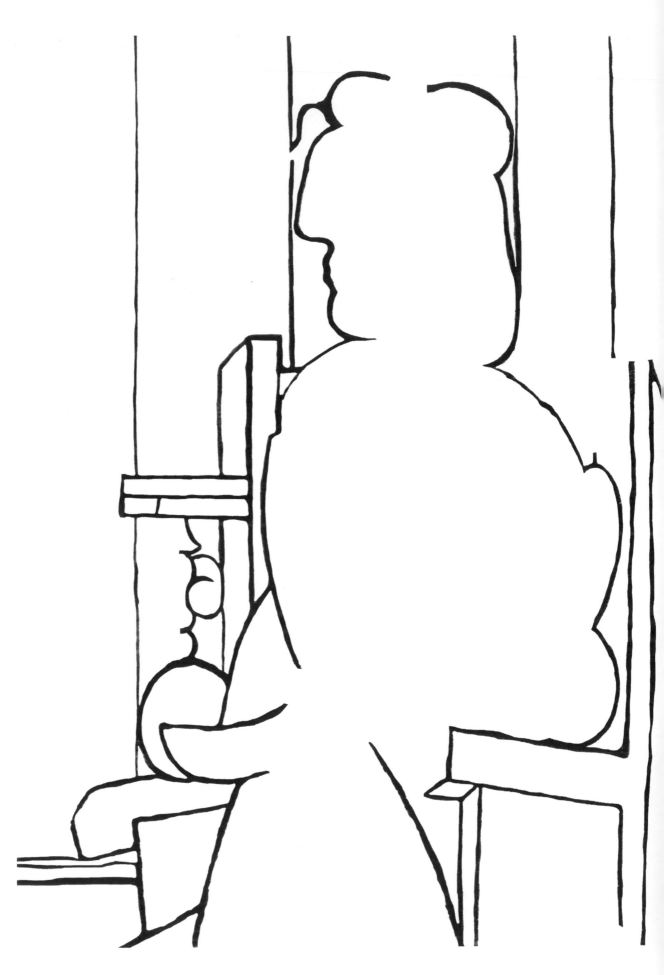

Pablo Picasso

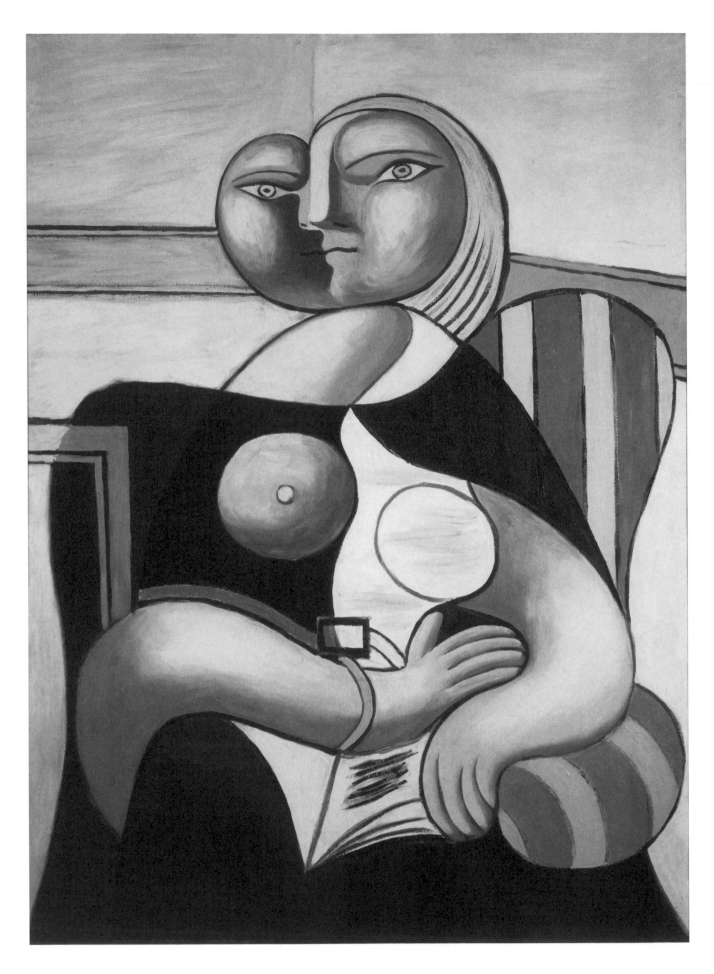

Woman Reading, 1932

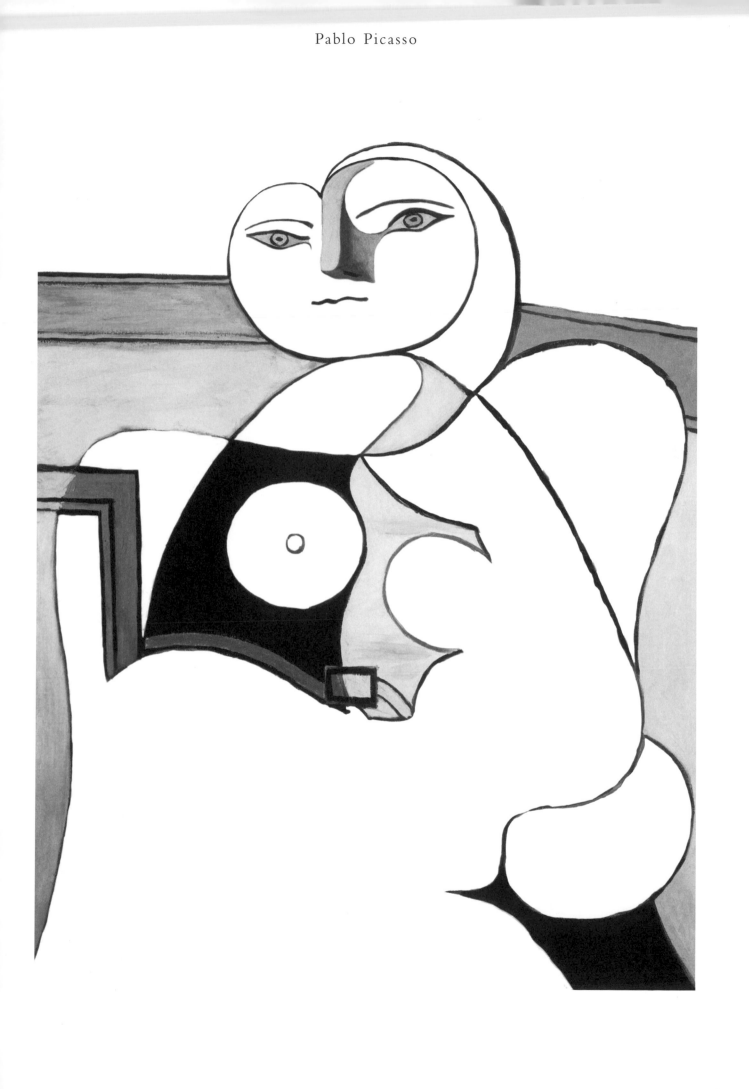

Pablo Picasso

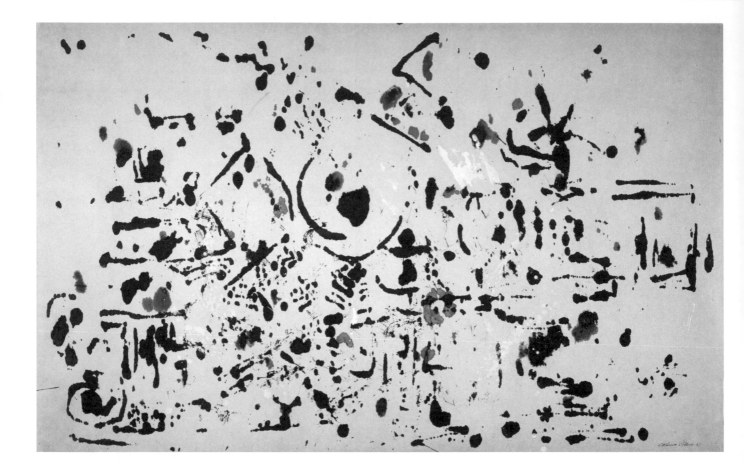

Untitled, 1951

© The Pollock-Krasner Foundation
ARS, NY and DACS, London 2011

Jackson Pollock (1912–56)

The American artist Jackson Pollock was born in Wyoming and moved to New York in 1930, where he studied painting. From 1938 to 1942 he worked for the Federal Art Project, part of Roosevelt's New Deal. In 1945 Pollock married fellow artist **Lee Krasner**. A major figure in the abstract-expressionist movement, Pollock pioneered the 'all-over' painting technique and the practice of placing the canvas on the floor and flinging paint against it; he also smeared household paint, broken glass and sand on to his large canvases. By the early 1950s, at the height of his fame, he abandoned his famous 'drip' technique. Frustrated by viewers trying to find representational elements in his work, he stopped naming his paintings and numbered them instead. Having suffered from alcoholism for most of his life, Pollock died from a drink-related driving incident.

Jackson Pollock

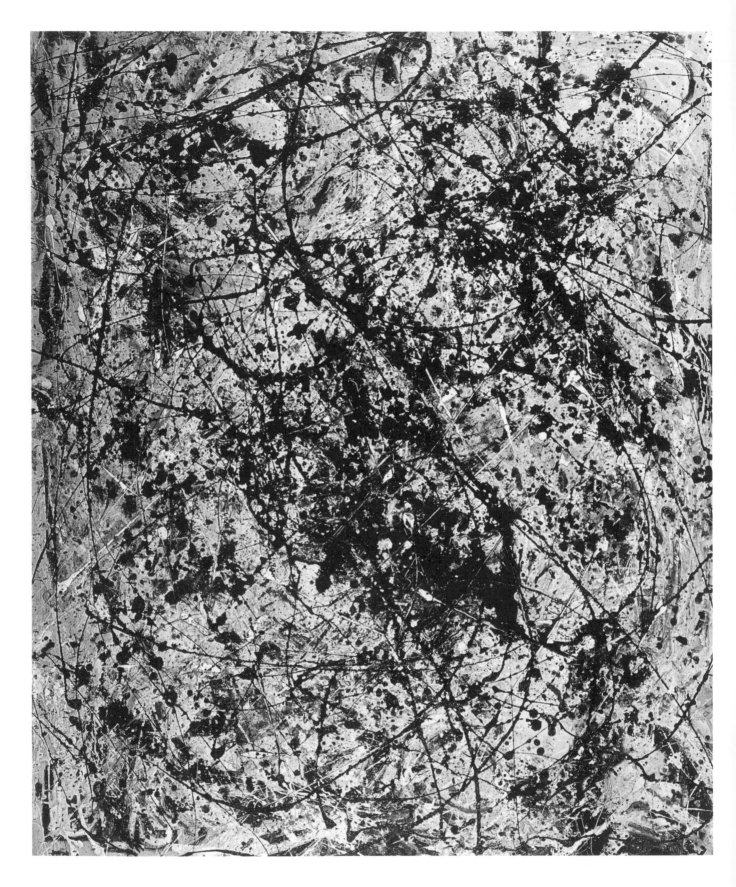

Reflection of Big Dipper, 1946

Jackson Pollock

Jackson Pollock

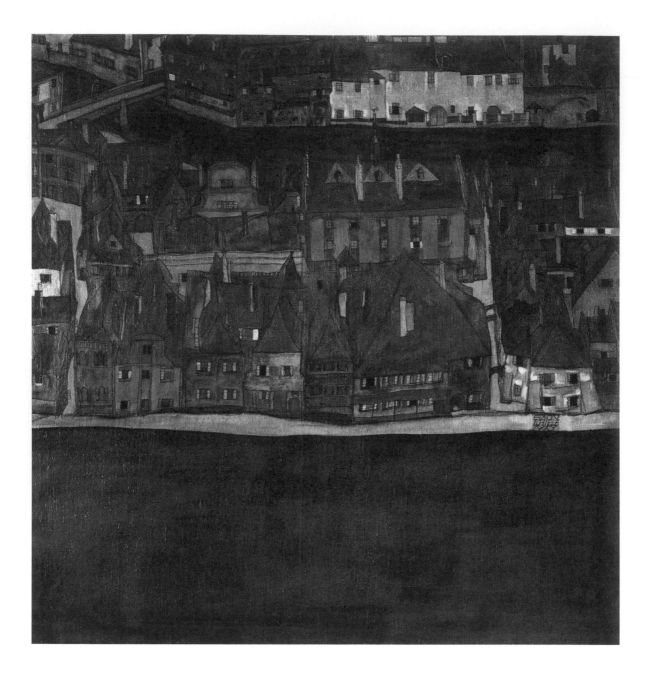

The Small City II, 1912-3

Egon Schiele (1890–1918)

Egon Schiele was an Austrian expressionist painter who was strongly influenced by Jugendstil ('youth style'), the German equivalent of the art-nouveau movement. He studied painting and drawing in Vienna from 1906, and a year later made himself known to **Gustav Klimt**, who invited him to exhibit his paintings at the 1908 Vienna Kunstschau. Schiele abandoned the decorative techniques of Jugendstil and adopted a much more expressive painting style. He gave his figures exaggerated postures and an angular elegance. He restricted his palette and his brushwork, using spare but precise strokes similar in style to Chinese brush painting. Many found reasons to criticize his subject matter, much of it sexually explicit, and he was once imprisoned for exhibiting paintings of nudes. In 1915 he was drafted into the Austrian army, but he returned to Vienna and painting in 1917. Schiele, like Klimt, died in the flu pandemic of 1918–20.

Egon Schiele

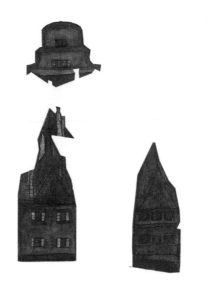
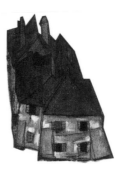

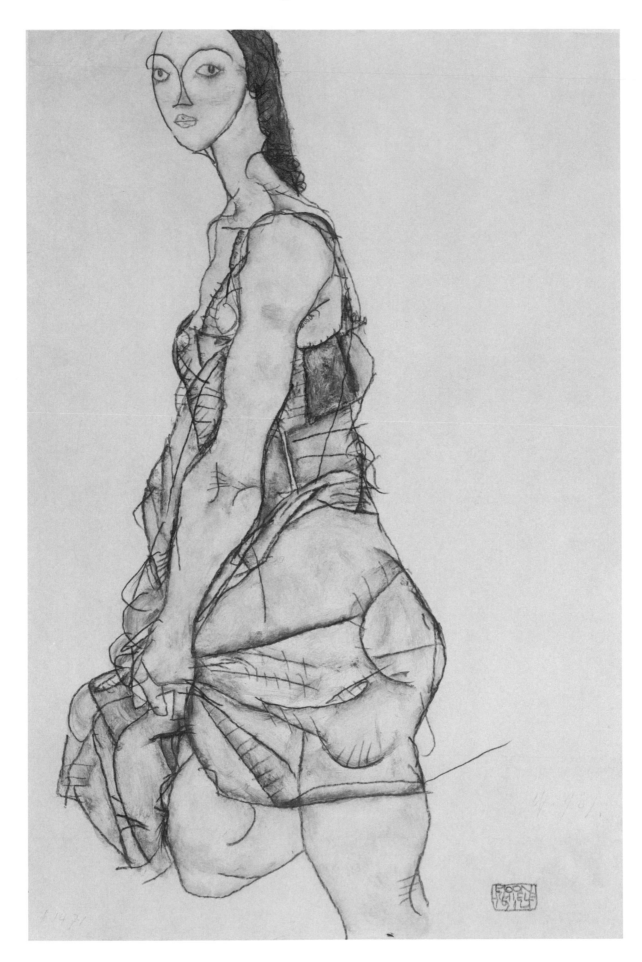

Upright Standing Woman, 1912

Egon Schiele

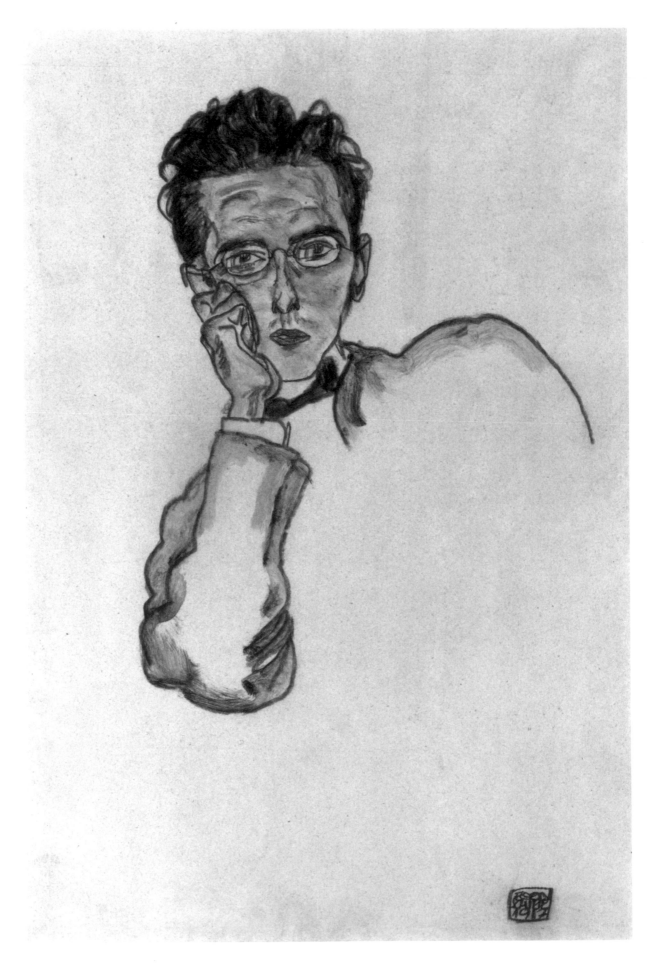

Portrait of the Art Dealer, Paul Wengraf, 1917

Egon Schiele

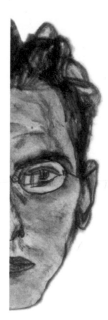

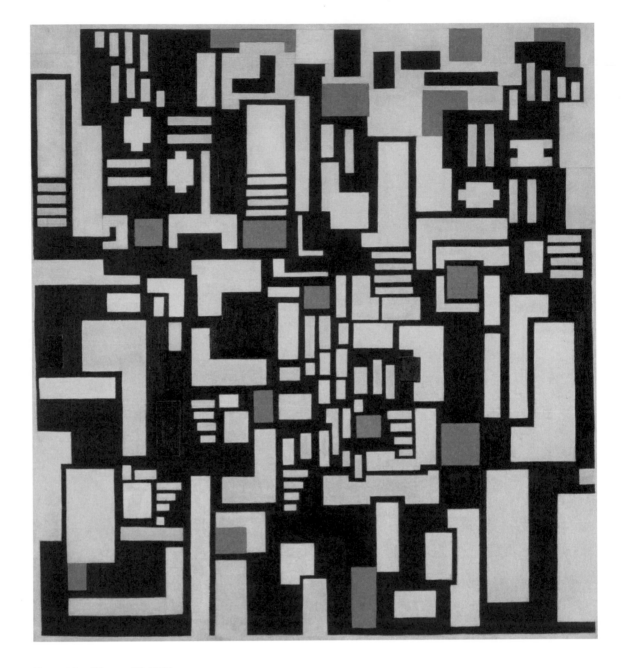

Composition IX, opus 18, 1917

Theo van Doesburg (1883–1931)

The avant-garde Dutch painter, poet, architect and designer Theo van Doesburg founded, with Piet Mondrian, the movement known as De Stijl ('The Style') during World War I. This aimed for a new style of art and design based on strict geometry, although van Doesburg was also involved with Dada, a movement opposed to the aims of De Stijl. He worked closely with Mondrian, both using geometric shapes, primary colours and black horizontal and vertical lines. However, van Doesburg began to use diagonal lines, to which Mondrian objected, although the two were later reconciled. Van Doesburg explored the reduction of natural objects into simple geometric forms – first through stained glass and later through architectural design. He moved to Weimar, Germany, in 1921 where he taught and designed houses, before moving to France in 1923. For a time his influence as a painter had been considerable, but later he produced significant work as an architect and writer, and in design, including typography.

Theo van Doesburg

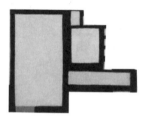

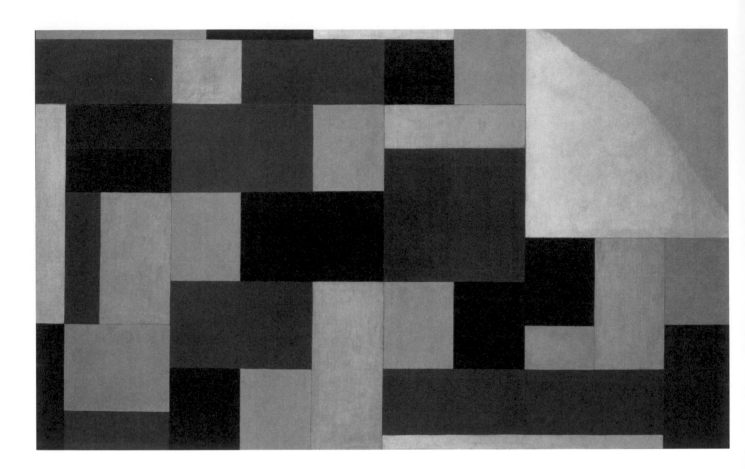

Composition, 1920

Theo van Doesburg

Theo van Doesburg

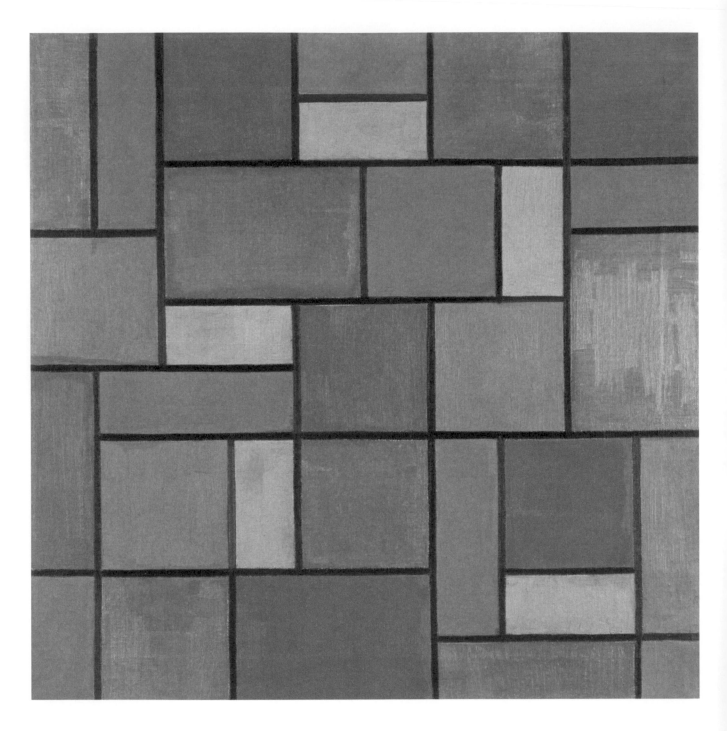

Composition XVII, 1919

Theo van Doesburg

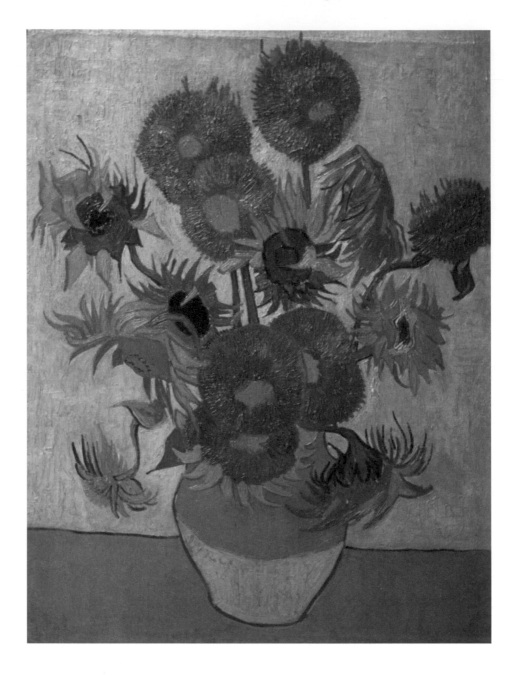

Sunflowers, 1888

Vincent van Gogh (1853–90)

The Dutch post-impressionist painter Vincent van Gogh did not take up art full-time until 1880. In 1886 he moved to Paris and met among others **Paul Gauguin** and Edgar Degas. Although inspired by the impressionist movement, he wanted to paint works of greater emotional impact. He began using thick paint, swirling, broken brushstrokes and vivid, contrasting colours. He painted in a hurry and would often squeeze paint straight from the tube on to the canvas, while the style of his drawing and painting varied considerably. On 23 December 1888 van Gogh confronted the artist Paul Gauguin with a razor, but subsequently cut off his own left ear. Van Gogh died on 29 July 1890 from a bullet wound to his chest. The verdict was that he shot himself, although modern research casts some doubt on this. In his lifetime he only sold one painting; today paintings by van Gogh are the most expensive in the art world.

Vincent van Gogh

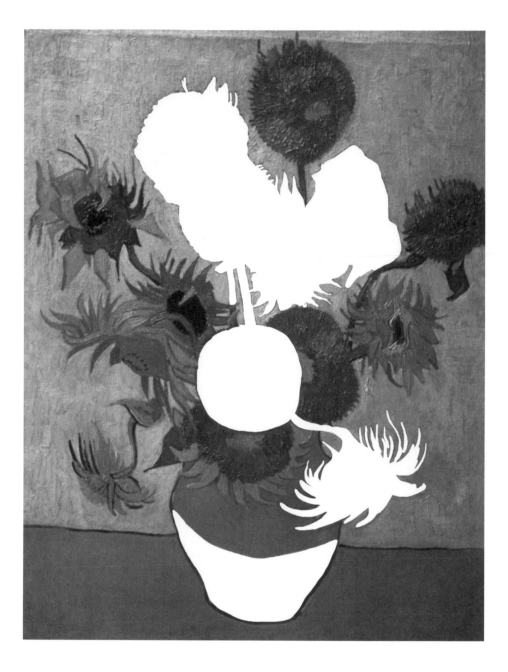

Focus on shape: For this first page try to add your interpretation
of the sunflowers. Whatever you decide to paint or colour in, be inspired
by van Gogh's original and expressive style.

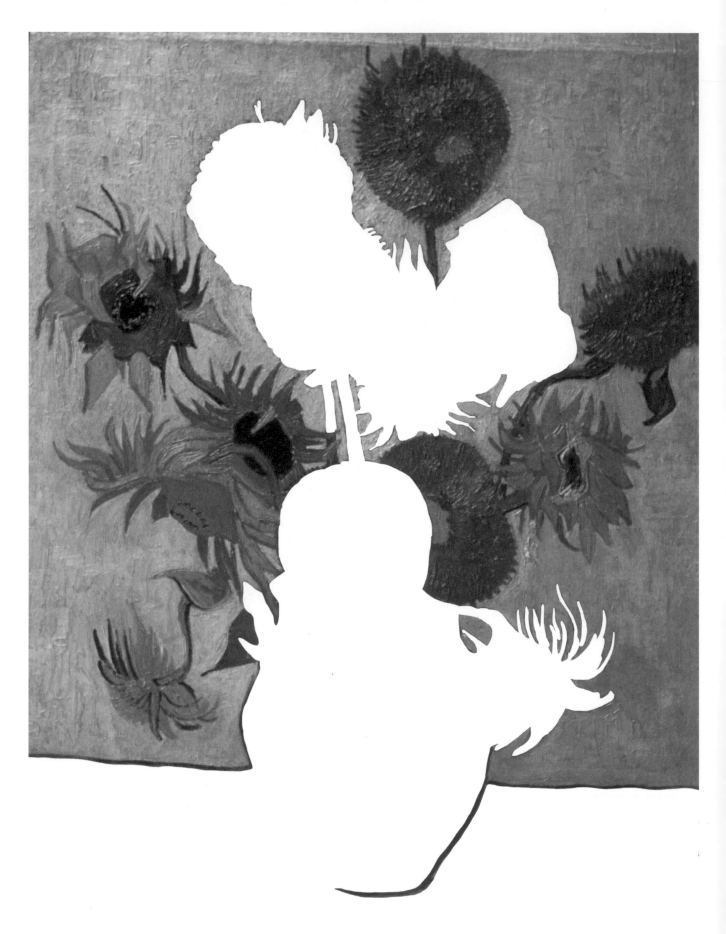

The Modern Art Doodle Book
Photo credits in order of appearance

Pierre Alechinsky

Particular Gravitation, 1981 (acrylic on paper mounted on canvas)
Alechinsky, Pierre (1927–) / The Israel Museum, Jerusalem, Israel /
© DACS / Vera & Arturo Schwarz Collection of Dada and Surrealist
Art / The Bridgeman Art Library

In Ink Country, 1959
Alechinsky, Pierre (1927–) / Private Collection / © DACS / J.P.
Zenobel / The Bridgeman Art Library

Georges Braque

Guitar and Clarinet, 1918
Braque, Georges (1882–1963) / Philadelphia Museum of Art,
Philadelphia, Pennsylvania, USA / Louise and Walter Arensberg
Collection / © Peter Willi / SuperStock

Château de la Roche-Guyon, 1909
Braque, Georges (1882–1963) / Pushkin Museum of Fine Arts,
Moscow, Russia / © SuperStock / SuperStock

Leonora Carrington

Desert Dorgys, 1986 (tempera on masonite)
Carrington, Leonora (1917–2011) / The Israel Museum, Jerusalem,
Israel / © DACS / Vera & Arturo Schwarz Collection of Dada and
Surrealist Art / The Bridgeman Art Library

Jean Cocteau

Front Cover of *Le Chiffre Sept*, 1952 (pencil on paper)
Cocteau, Jean (1889–1963) / published by Seghers, Paris, France
1953 (black and white photo) / Bibliothèque Littéraire Jacques
Doucet, Paris, France / © DACS / Archives Charmet / The
Bridgeman Art Library

Clown With Guitar, date unknown
Cocteau, Jean (1889–1963) / © SuperStock / SuperStock

Salvador Dalí

St George, date unknown (acrylic)
Dalí, Salvador (1904–1989) / Private Collection / © DACS / Photo
© Bonhams, London, UK / The Bridgeman Art Library

Tamara de Lempicka

Model in the Studio, date unknown (oil on wooden board)
de Lempicka, Tamara (1898–1980) / © Christie's Images Ltd. /
SuperStock

Jean Dubuffet

Mouchon Berlogue, 1963
Dubuffet, Jean (1901–85) / © ADAGP Banque d'images, Paris 2012

Marcel Duchamp

Nude Descending Staircase Number Two, 1912 (oil on canvas)
Duchamp, Marcel (1887–1968) / Philadelphia Museum of Art,
Philadelphia, Pennsylvania, USA / © SuperStock / SuperStock

Max Ernst

Die Ganze Stadt, 1953–6
Ernst, Max (1891–1976) / Kunsthaus Zürich, Zürich, Switzerland /
© SuperStock / SuperStock

Gala Eluard, 1926 (engraving) (black and white photo)
Ernst, Max (1891–1976) / Illustration for *Au Défaut du Silence* by
Paul Eluard (1895–1952) / Private Collection / © DACS / Archives
Charmet / The Bridgeman Art Library

Paul Gauguin

The White Horse, 1898
Gauguin, Paul (1848–1903) / Musée d'Orsay, Paris, France /
© Peter Willi / SuperStock

Natalia Goncharova

Rayonist Flowers, 1914 (oil on canvas)
Goncharova, Natalia (1881–1962) / © SuperStock / SuperStock

The Reaping. Phoenix, 1911
Goncharova, Natalia (1881–1962) / State Tretyakov Gallery,
Moscow, Russia / 1911 / 100 x 91 / oil on canvas / Russian avant-
garde / Russia / © Fine Art Images / SuperStock

Patrick Heron

Nude in Wicker Chair: 1951, 1950–1
Heron, Patrick (1920–99) / The Sherwin Collection, Leeds, UK /
The Bridgeman Art Library

Icy Emerald Cutting into Dark Green and Blue (Cobalt and Violet Discs): November 1968, 1968 (gouache on paper)
Heron, Patrick (1920–99) / 23-5/8 x 30-5/8 inches / Fred Jones Jr. Museum of Art, University of Oklahoma, USA / Gift of Max Weitzenhoffer / The Bridgeman Art Library

January 19: 1989, 1989 (gouache on paper)
Heron, Patrick (1920–99) / Private Collection / The Bridgeman Art Library

David Hockney
Apple, Grapes, Lemon on a Table (for Bam), 1988 (home-made print on two sheets of paper)
Hockney, David (1937–) / Edition of 91 / 14 x 17 inches / © David Hockney

Wassily Kandinsky
Graues Viereck, 1923 (B.a 620) (pen and ink and watercolour)
Kandinsky, Wassily (1866–1944) / Private Collection / © DACS / Photo © Lefevre Fine Art Ltd., London, UK / The Bridgeman Art Library

Deutliche Verbindung, 1925 (B.a 768) (watercolour and pen and black ink on paper)
Kandinsky, Wassily (1866–1944) / Private Collection / © DACS / Photo © Christie's Images Ltd./ The Bridgeman Art Library

Paul Klee
The Flower Wishes to Fade, 1939 (watercolour on paper)
Klee, Paul (1879–1940) / Barnes Foundation, Merion, Pennsylvania, USA / © Barnes Foundation / SuperStock

Symbols on a White Background, 1940 (oil)
Klee, Paul (1879–1940) / Felix Klee Collection, Berne, Switzerland / © Peter Willi / SuperStock

Heroic Roses, 1938 (no.139) (oil on burlap)
Klee, Paul (1879–1940) / Kunstsammlung, Nordrhein-Westfalen, Düsseldorf, Germany / The Bridgeman Art Library

Gustav Klimt
The Kiss, 1907–8 (oil on canvas)
Klimt, Gustav (1862–1918) / Osterreichische Galerie Belvedere, Vienna, Austria / The Bridgeman Art Library

Lee Krasner
Mysteries, 1972 (oil on cotton duck)
Krasner, Lee (1908–84) / Brooklyn Museum of Art, New York, USA / © DACS / Dick S. Ramsay Fund / The Bridgeman Art Library

Meteor, 1971 (oil on canvas)
Krasner, Lee (1908–84) / Private Collection / © DACS / The Bridgeman Art Library

František Kupka
Maquette for *Fugue in Two Colours,* 1912 (oil on canvas)
Kupka, František (1871–1957) / Private Collection, Paris, France / © DACS / Peter Willi / The Bridgeman Art Library

Study for *Around a Point*, date unknown
Kupka, František (1871–1957) / Christie's Images, London, UK / © Christie's Images Ltd. / SuperStock

Fernand Léger
Composition, date unknown
Léger, Fernand (1881–1955) / Russia, St Petersburg, Hermitage Museum © SuperStock / SuperStock

Untitled, 1942
Léger, Fernand (1881–1955) / Private Collection / © SuperStock / SuperStock

Roy Lichtenstein
Reclining Nude, 1980 (oil and magna on canvas)
Lichtenstein, Roy (1923–97) / Private Collection / © DACS / Mayor Gallery, London, UK / The Bridgeman Art Library

Woman With Flowered Hat, 1963 (magna on canvas)
Lichtenstein, Roy (1923–97) / Private Collection © SuperStock / SuperStock

René Magritte
Golconda, 1953 (oil on canvas)
Magritte, René (1898–1967) / Menil Collection, Houston, Texas, USA / Bridgeman Art Library / SuperStock

Le principe d'Archimède, 1952 (gouache on paper)
Magritte, René (1898–1967) / © Christie's Images Ltd. / SuperStock